smorgasbowl

recipes and techniques for creating satisfying meals with endless variation

Radicle Publishing

smorgasbowl

recipes and techniques for creating satisfying meals with endless variation

979-8-9850723-0-3 Paperback

979-8-9850723-1-0 Hardcover

979-8-9850723-2-7 e-book

Library of Congress Control Number: 2021920483

Printed in the United States of America

smorgasbowl

recipes and techniques for creating satisfying meals with endless variation

Written *and* Photographed by

Caryn Jeanne Carruthers

creator of tastynfree.com

Radicle Publishing

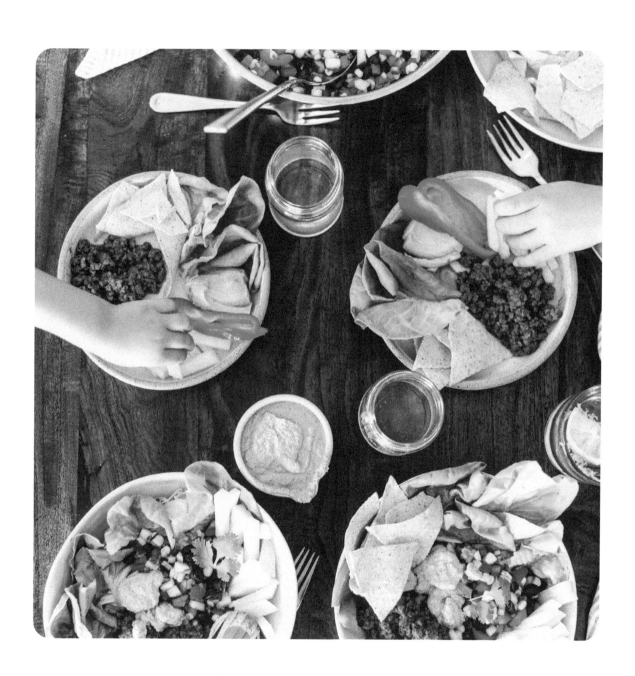

For my family, who unintentionally make me the best version of myself.

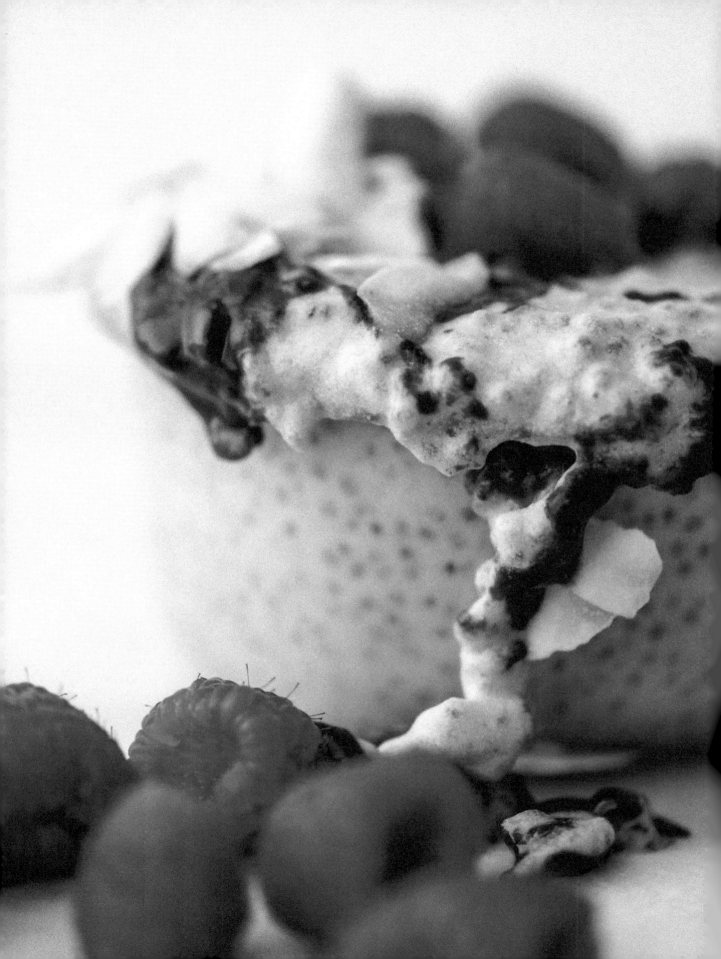

CONTENTS

INTRODUCTION

Smorgasbowl isn't only a fun word to say, it's a fun way to eat! Smorgasbowls are a simple and effective way to create meals that inspire. They hold our favorite ingredients together in a bowl and transform them into a meal greater than the sum of its individual components. When stuck in an uninspired food rut or accommodating food allergies, smorgasbowls will free you. Smorgasbowls work for everyone because there isn't a need to create a composed recipe, rather, you combine ingredients and components at will, adding only what you desire. Learning the smorgasbowl system will allow you to eat delicious food for every meal with less burden, regardless of dietary choices.

Smorgasbowls are my primary way of eating. A few years ago, I cut grains out of my diet and started eating mostly veggies and meat. I had to rethink the elements of my meals sans a carb-y base. My new diet included familiar foods that had new preparations, textures and sauces. Nothing was quite melding the way I wanted them to on a flat plate so I started reaching for the beautifully crafted low bowls from my cabinet. At first I wasn't conscious of the change, but soon realized I was using a bowl for every meal!

The shift to a new eating vessel opened up a new way of eating that is full of flavor, nutrient dense and extremely versatile. The veggies and meat that often hid under bread were now exposed. They needed to be cooked well, seasoned well and layered with other flavors. I started conceiving meals based on how everything would taste together in one bite. I started thinking about how the layered components would complement and improve the meal overall. Smorgasbowls have become my favorite way of eating, and something worth sharing.

Here's what I love about smorgasbowls:

- Smorgasbowls are great for people with dietary restrictions — and the people who eat with them! My recipes contain very little dairy, grain or sugar. But for those without restriction, add a scoop of yogurt, some rice, a pita or whatever else. No one suffers because everyone is eating from their own, individually assembled bowl!
- Creating meals for families with differing taste preferences is easy with smorgasbowls. Each family member can add the components they like and leave out the ones they don't. Some can keep their components separate and mild, and others can layer on the sauces and add something spicy to create a complex flavor profile.
- Entertaining with smorgasbowls is fun and puts guests in control of what ends up in their bowls —just stack up the bowls in front of a buffet of smorgasbowl components.
- Eating smorgasbowls throughout the week cuts down on cooking time because you can create new, delicious smorgasbowls from leftovers — meat, salad, cooked veggie and sauces — by simply rearranging what they are with.

Throughout this book I share with you the building blocks and secrets to building your own bowls. I've also included some of my favorite recipes. I am excited for you to start experimenting eating smorgasbowls in your home and with your family. I hope you discover some new favorite meals and find ideas for cooking at home that make your life more enjoyable.

Happy Eating!

Caryn

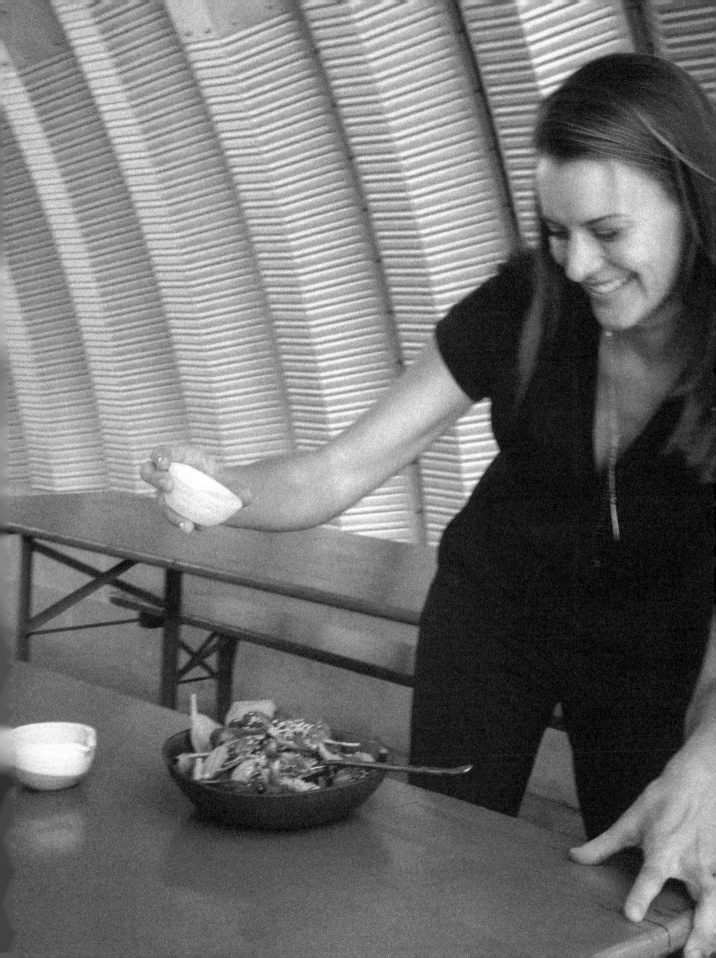

THE FOUR PILLARS OF A BALANCED SMORGASBOWL

A beautiful thing about smorgasbowls is the ease with which you can create balance in your meal because you aren't cooking a formal dish, but combining components at will. That doesn't mean you can just throw any odd thing into a bowl and expect to create Michelin Star-worthy fare. Every successful smorgasbowl is delicately balanced on the four pillars of flavor, nutrition, texture and temperature. Come up short on any of them and your bowl will fall out of balance and your plans for a satisfying meal may fall with it. Each bowl must be balanced in:

Taste/Flavor: This should be your number one consideration when building a bowl, because how your bowl tastes will ultimately be what brings you back to a recipe. The raw components alone as well as how each component is cooked, prepared, seasoned, spiced and combined with other components is an opportunity to build flavor. Some components, like fruit and cheese, pack a punch of flavor on their own. But most meat, veggies, and carbs need a little help to become flavorful. Here is a list of ways to add flavor:

- browning (either on the stove or in the oven)
- salt
- acid
- herbs
- spices

When you are ready to take your bowl skills to the next level, start considering how to incorporate a spectrum of flavor (sweet, umami, spicy, bitter, sour and salty) into your bowl for a well-rounded and balanced profile of flavors.

Nutrition: If you are being honest with yourself, no one knows better than *you* what your perfect nutritional balance looks like. But generally speaking, your bowl should have a complement of protein, fiber, carbohydrates and fat. My ideal bowl is primarily protein and fiber, with carbohydrates and fat playing a supporting role.

Texture: To be fair, texture isn't something that is important to everyone, but for most of us, the subtleties of crunchy, meaty, smooth and saucey food either adds or severely detracts from the experience of eating it. Because of this, think about the different textures ingredients can offer when you are building your bowl and consider the experience of eating whatever you are making. When you are ready to take your bowl to the next level, start incorporating contrasting textures. For example, if you've got a bunch of soft food with a sauce, how are you adding some crunch? Or if your salad is taking you forever to choke down, incorporate something soft and/or saucy to make the experience more enjoyable.

Temperature: The temperature of food completely changes our experience of it. Consider the last time you pulled leftovers out of the fridge and they smelled terrible until they were heated in the microwave. There is no right or wrong when it comes to the temperature of your smorgasbowl (as long as meat and eggs are at a safe temperature to eat and cooked through if needed). The consideration is contrast. A cold dollop of sour cream takes hot soup to a higher level. Warm grains make greens taste so comforting. No need to overthink temperature, but if you're accustomed to eating meals that are only hot or only cold, consider a mix and match experience — just remember that hot food will cook anything it touches in the bowl once it is plated (or bowled, as it were).

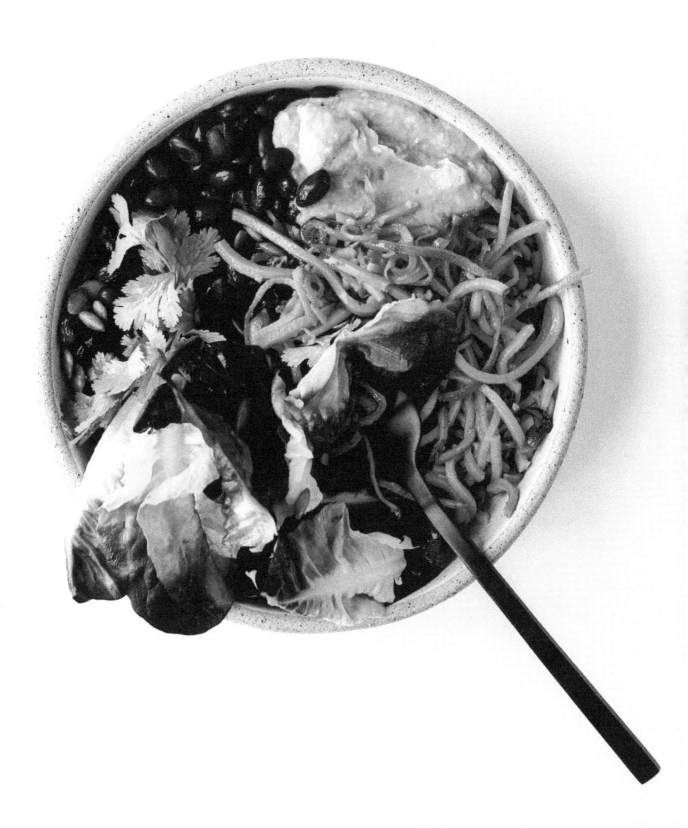

FLAVOR EXAMPLES

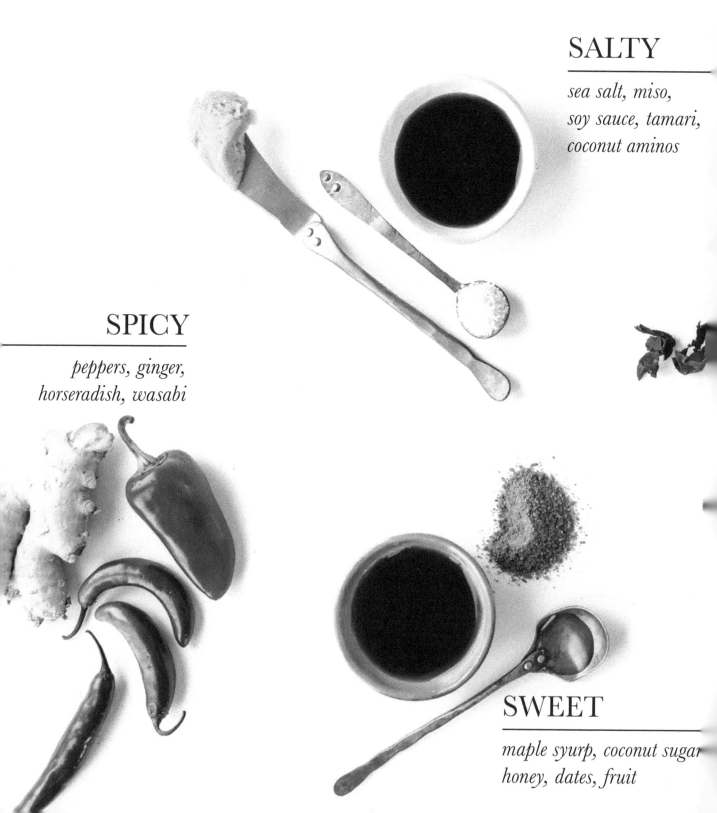

SALTY

*sea salt, miso,
soy sauce, tamari,
coconut aminos*

SPICY

*peppers, ginger,
horseradish, wasabi*

SWEET

*maple syurp, coconut sugar
honey, dates, fruit*

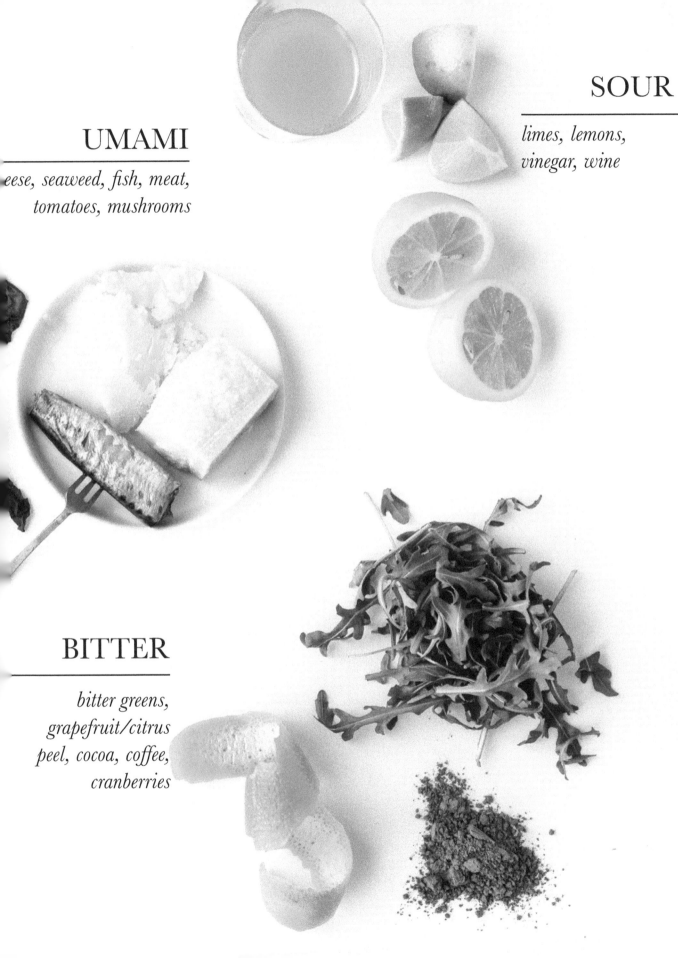

UMAMI

eese, seaweed, fish, meat,
tomatoes, mushrooms

SOUR

limes, lemons,
vinegar, wine

BITTER

bitter greens,
grapefruit/citrus
peel, cocoa, coffee,
cranberries

SMOOTH / SOFT

cooked grains, pasta,
root veggies, avocado

CRISPY/CRUNCHY

chips, nuts, seeds, greens,
herbs, raw veggies

MEATY

*eef, pork, poultry, fish,
beans, tofu, tempeh*

THIN SAUCE

*dressings, citrus juice, oil,
vinegar, broth*

THICK SAUCE

alfredo, pesto, hummus, gravy

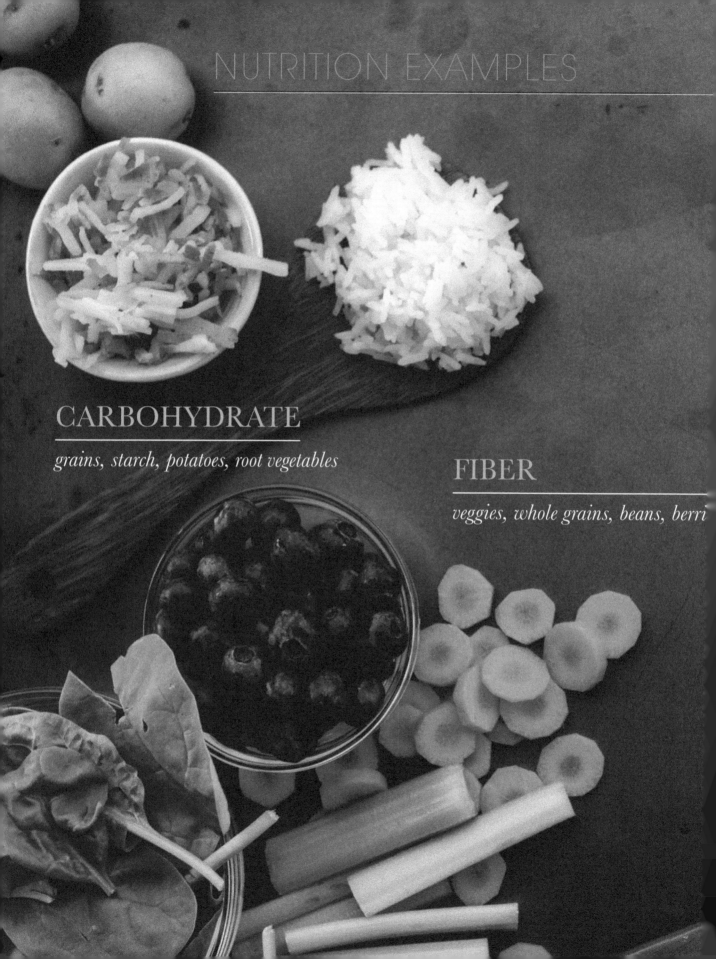

CARBOHYDRATE

grains, starch, potatoes, root vegetables

FIBER

veggies, whole grains, beans, berri

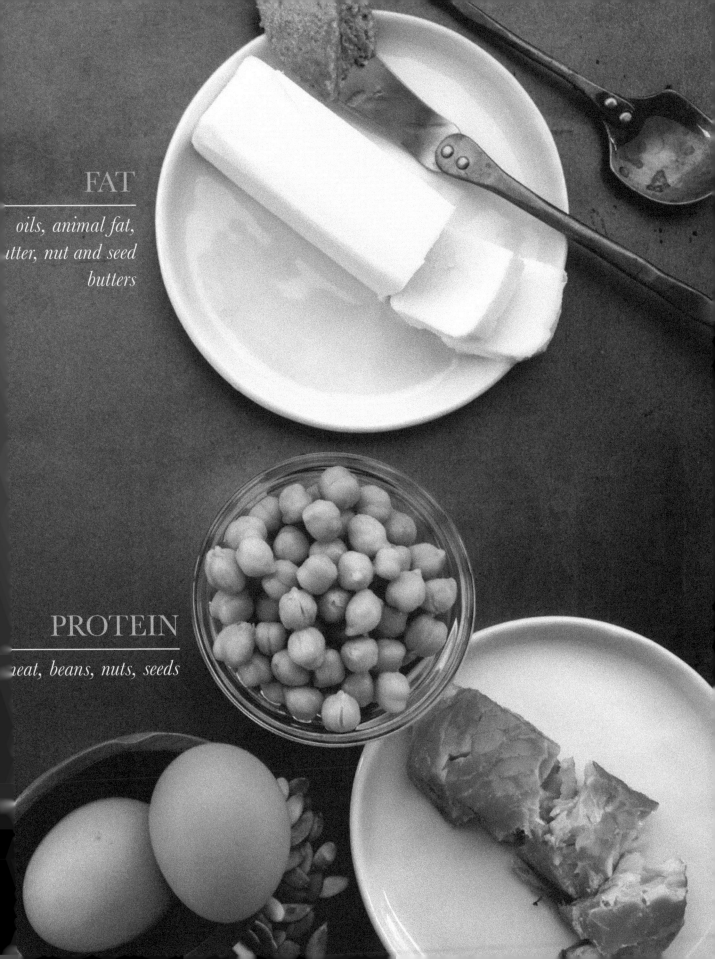

FAT

*oils, animal fat,
...tter, nut and seed
butters*

PROTEIN

...eat, beans, nuts, seeds

HOT

just cooked

ROOM TEMPERATURE

from the counter or pantry

COLD

from the fridge or freezer

AN EXAMPLE BUILD

Let's walk through a bowl building process together. To start, I decided on Mexican-cusinie inspired flavors, probably because I had pre-made guacamole, canned black beans and pepitas on hand. (I buy seeds and nuts in bulk online and store them in my freezer because it is quick and easy to toast them up and add them to almost everything). Knowing I had protein (beans), sauce (guacamole) and a crunchy topping (pepitas) covered, I decided on a heated base: spiralized and pan-cooked sweet potatoes, which add a warm, carb-y component. Next, I added prepackaged, pre-washed greens from the fridge for something fibrous, and lastly fresh cilantro and a quick squeeze of lime on top.

CILANTRO

LIME

TOASTED PUMPKIN SEEDS

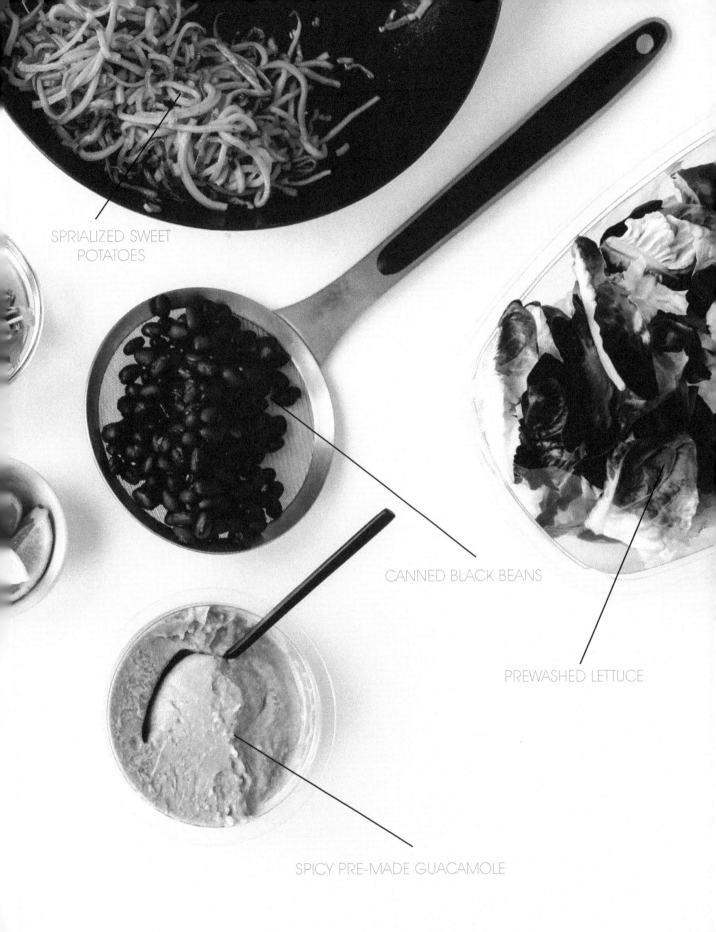

SPRIALIZED SWEET
POTATOES

CANNED BLACK BEANS

PREWASHED LETTUCE

SPICY PRE-MADE GUACAMOLE

THE BUILD

Here is primary contribution of each component in terms of:
flavor, texture, nutrition and *temperature*

PUMPKIN SEEDS
salty + crunchy

LIME
acid

GUACAMOLE
spicey/salty/acidic + fat

LETTUCE
crunchy + fiber + cold

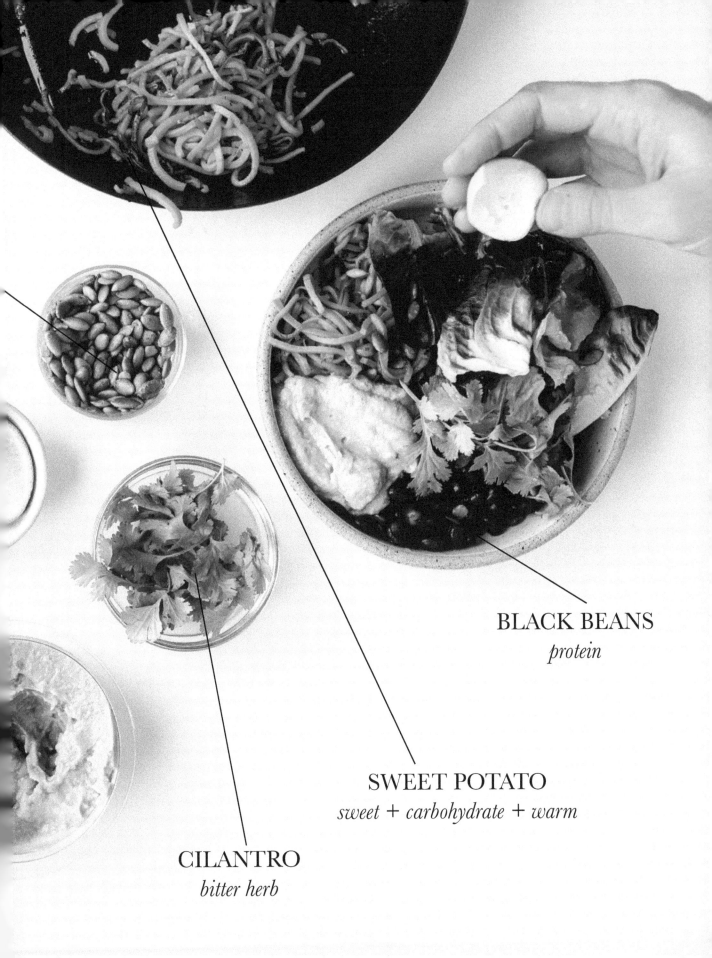

BLACK BEANS
protein

SWEET POTATO
sweet + carbohydrate + warm

CILANTRO
bitter herb

SMORGASBOWLS LOVE VEGGIES

Eat your veggies. That's the thing that echoes in our heads right? Probably because it is something every mother has said at least a million times. And since mamas usually get it right, the fact remains: We should eat our veggies. But you know what? Sometimes, eating a lot of vegetables can be hard to swallow. I eat *a lot* of vegetables, and sometimes I choose to *not eat* instead of pulling raw carrots out of the fridge and attempting to choke them down. Don't get me wrong. It isn't that I don't *like* veggies — I definitely do — but I often find myself staring into my fridge's veggie crisper wondering how I could possibly eat something tasty with those beginnings. Hear this when I say *tasty:*

- *Super scrumptious*
- *Sink-your-teeth-into delicious*
- *Satisfying*
- *Hearty*
- *Comforting*

Now, raw veggies are a lot of things, but on their own (for the most part) I wouldn't say they are sink-your-teeth-into delicious, hearty or satisfying. But they're good for us and they make our bodies strong, healthy and energized. I won't settle for not enjoying my food nor an unhealthy body so the only option is figuring out how to get more *tasty* veggies in my diet. Smorgasbowls have not only solved this dilemma, they also continue to deliver on a daily basis.

So here is what I've discovered. Somehow — magically maybe — when veggies sound terrible, if you cook them, combine them with other raw veggies or add a sauce and/or protein like meat or beans to them… *voila!* Veggies find a new home among the comforting, fulfilling food of your dreams. I have thought a lot about why this happens, and here is the best I can do to describe it: when your bowl is holding all of the pieces of your meal lovingly together, all the food gets better for being exposed to one another. It is like a dinner party with guests of every personality: spicy tastes better because there's oil; salty finds the acid; crunchy finds its way next to something soft; heat gets a crunchy, cool partner. And it all gets *balanced,* like a perfect party in your mouth should be.

In this book you are going to find a lot of different veggies put together in different ways and prepared with different techniques. You'll discover many of my favorite ways to prepare veggies as you cook through the recipes. I hope you'll find some new techniques to incorporate into your everyday cooking. Be ready to execute them when you go to create your own bowls — complete with plenty of veggies.

SECRETS TO SUCCESSFUL SMORGASBOWLS

Over the years I've eaten hundreds of smorgasbowls. And even though the ingredients in them vary wildly, my favorites often have a lot of things in common. Not all bowls incorporate all these secrets at the same time, but if you are looking down into your bowl and thinking: *meh, this could be better,* read through this list and pick a few ideas to work on next time.

The best bowls have:

1. **Nutritional balance.** The perfect nutritional balance is a little different for everyone and I am not your doctor. I will not make broad statements that a certain percentage of each nutritional component is needed. Instead, I am going to suggest you eat what feels good (not just on the tongue, but for many hours and days afterward) and heed the following method: When creating a nutritionally balanced bowl, start by adding fiber (greens, veggies), then protein (beans, nuts, meat) and then fat (butter, oil, nuts, animal fat). Once you've accounted for fiber, protein and fat, then — and with a light hand — add sugar (fruits, sweeteners) and carbohydrates (grains, potatoes).
 Since fat's role as a proportion to the whole sits in a position of controversy, let me offer this: If you are adding more carbs to the bowl, do less fat and if you've only got green veggies in your bowl, add more fat. Always pay attention to the nutritional balance that gives you the physical response that feels best to you in the long run (i.e. healthy and strong with a clear mind), regardless of popular opinion.
2. **Acid.** Your bowl needs acid for balance. I can't stress this strongly enough. Acid adds brightness, balances flavor and can turn a mediocre bowl into a great one. Don't forget the citrus, vinegar or wine when you are planning your bowl — but remember that a little goes a long way.
3. **A lot of color.** Eat the rainbow. Color occurring naturally in food is an indication of nutrients, and it just tastes better to have more of it. Seriously.
4. **Seasonal ingredients and preparations.** Food is going to taste the best when it is fresh and in peak season, so buy your food in season and eat it at its peak (or better yet, grow your own!). Think about grilling in the summer and roasting in the winter. Eating and cooking with the seasons just tastes better.
5. **Fresh ingredients.** Ok, maybe this one goes without saying, but I am going to say it anyway. Don't pull your two-week-old box of greens out of the fridge, microwave some frozen corn and add in a questionable piece of fish from your fridge. It's not going to taste good. Ask me how I know.
6. **Cuisine-centered flavors.** When you are needing a theme for your bowl, or you are looking for inspiration, look to the cuisines that have been perfecting flavor profiles for centuries, i.e. Mexican, Indian, Thai, Italian, French, etc.
7. **Keep seeds and nuts on hand.** Rather than toasting a few seeds or nuts to incorporate into a single recipe, I like to toast a full pan of them every couple of weeks and store them in a cool, dry place. This way, I'll always have them at the ready to add a bit of crunch to any bowl. Almost everything tastes better with toasted sesame seeds sprinkled on top!
8. **Balance.** Don't do too much of one thing. Read and heed the The Four Pillars of a Balanced Smorgasbowl section. Balance isn't easy and there isn't a perfect equation, but it's worth striving for.
9. **Homemade components (or at least not entirely store-bought components).** There is an abundance of store-bought sauces, salads, grain salads, veggie mixes, prepared meats, soups and many other things that will work beautifully as a component or two in your bowl. And items like prewashed lettuce and fresh-made guacamole have been lifesavers for me. Where you start to go wrong is when you lean on the pantry and the premade stuff entirely. You may need a freshly chopped veggie or homemade

sauce to balance out the strong flavors of store-bought ingredients (and their additives!).

10. **Season each component separately.** Each component of your bowl should taste good on its own. Don't rely on one component for all of the salt in a dish because you aren't going to be able to control that method well enough. What's easier is seasoning each thing so it tastes balanced on its own (nicely salty, balanced with acid). The resulting bowl will be so much more than the value of its separate parts. If you have leftovers of anything, each component will stand on its own for the next bowl you create with it.

11. **Careful knife work.** Make sure the pieces in your bowl are roughly the same size so they cook evenly. Evenly sized pieces also ensure you are able to get nice amounts of each thing on your fork at the same time.

12. **Fresh herbs.** Fresh herbs will take your bowls from good to great. Add them liberally, grow your own and get creative with what herbs you use where. Traditionally savory herbs can enhance and balance sweet flavors, and mint can be an exciting addition to savory dishes. Experiment. Pay attention to texture. Young, fresh leaves are what you want. Avoid anything that has flowers or looks too woody, and remove the leaves from the stems. Cilantro and parsley stems can be fine when chopped small.

13. **A creator who is willing to try new things.** My best and worst meals were created when I was willing to try out new combinations, cooking methods and ingredients. If you're willing to brave the failures, your bowls will only get better.

WHAT NOT TO DO

You know I have had some bowl failures. You may have some, too. If you do, think specifically about what you don't like about your bowl and revisit the Four Pillars and Secrets to a Successful Smorgasbowl sections. I'll save you some time and list some of the reasons for my failures.

Avoid your bowl being:

1. **Bland.** Use salt, pepper, acid, spices and herbs. Taste while you are cooking so you can adjust as needed.

2. **Only raw vegetables.** Eating raw veggies can be a badge of honor, but it can also be hard to choke down. Mix in some fats, oils, cooked veggies or grain and see if you can't get those raw veggies down a little easier.

3. **Monochromatic**. Food with color not only adds nutrients, but also texture and flavor.

4. **Dominated by processed ingredients.** Flavors and textures of processed ingredients — like canned soup or fritos — are bold and can over-power your bowl, so use them sparingly.

5. **Without variety.** Instead of copping out and settling for plain lettuce and some nuts (guilty) cook extra veggies or meat with dinner the night before so you have something easy to pull out of the fridge to heat up to add to your lunch bowl the following day.

6. **Too dry, with no sauce.** The sauce makes or breaks a bowl, period.

7. **Without contrast.** When your bowl is homogenous in temperature and/or texture (all warm and smooth or all cold and crunchy) consider how to add contrast with different temperatures and textures. These contrasting dynamics enhance your eating experience.

8. **Made with old leftovers.** Leftovers in the fridge have 3-7 days in the fridge (depending on what they are) before they need to be used or thrown away. While I understand the hilariously frugal among us like to push these guidelines, food safety and flavor are at stake, so I tend to stick to them.

9. **Too complicated.** Pick two or three main things and then add a sauce. Think about your Thanksgiving plate or the bowl you made at a local fast casual joint that had too many sides and components all cramped into one space trying to get along. It's easier to enjoy bowls without too much going on.

SPECIALIZED EQUIPMENT NEEDED FOR RECIPES IN THIS BOOK

Food processor

For the recipes in this book, we will use the food processor for sauces and quick chopping or shredding of vegetables. Generally speaking, using a food processor will result in a chunkier suace, not completely smooth as it would be from a high speed blender. This is desireable for sauces like a olive tapenade, or something similar you want to still have recognizable bits of ingredients. The food processor I have has a s-blade that is used for anything that gets blitzed in the main container of the machine. The result is small, ununiform pieces. There is also a chopping and shredding blade which you feed the veggies through the top of the processor and they get shredded or sliced as you push them through the top.

High-speed blender

High speed blenders offer a special ability to get ingredients really smooth and uniform. I use my high speed blender a lot because I love how smooth the texture of the mixture can become with the power in these machines. High speed blenders have enough power to can take on tasks like making nut butters or sorbets. I like a high speed blender with a tamper, it allows you to keep the ingredients you are blending close to the blades without having to stop the blender. In this book we will use a high speed blender for smoothies, soups, pudding, humus, sauces, and nut milk (if you choose). I use my high speed blender a lot, and always clean it out quickly after using it, because it is a lot easier to clean out wet sauces than it is dry ones!

Squeeze bottle, and other dressing vessels

We make a lot of sauces in this book, and a squeeze bottle is a helpful tool for not only getting the sauce where you want it, but also giving your food a very put together appearance. You will feel like a real chef as you squeeze your homemade sauce on your bowl. It is fun to use, enhances the eating experience and makes your food look great! This humble kitchen tool will add a lot to your bowls.

Grill

In this book we will grill some veggies – something I am excited to share with you (page 78)! Any type of grill will work to grill veggies, but a gas grill is certainly a lot easier when it comes to getting the grill hot and ready for cooking. Regardless of whether you are using a gas or charcoal grill, make sure your grill is hot before putting the food on the grates, this with ensure proper cooking times and the grill marks you are looking for. If you are concerned about your ingredients sticking to the grill, you can (carefully, so you don't burn yourself!) run a folded cloth with oil on it over the grates before cooking. The cloth you use will get black on it from the grates, so don't use a cloth you can't wash or mind being stained.

Spiralizer

In this book we will spiralize sweet potatoes, apples, cucumbers and jicama. There are sometimes a number of blade options that come with a spiralizer. In this book we will use the smallest (mine is 3mm) spaghetti style blade. I tend to like the results from this blade the best for most of the things I make, but feel free to experiement. Having this tool on hand is great for adding interesting texture to the humble veggies we are accustomed to eating in other ways. Spiralizing is admittedly more of a playful indulgence than a necessity, but spiralizing your veggies will add a unique noodle-like texture that can enhance the experience of eating your meal.

NOTE TO THE READER

I hope this book is an inspiration as you continue your eating-at-home journey. The recipes in this book often have multiple components and are divided in the ingredients with sub headers. Components of any recipe will have many more uses, and using components on their own or in other dishes is not only encouraged but at the heart of what I hope to inspire you to do. For example, if you love the grilled veggies from the Grilled Veggies with Mung Beans and Sunflower Tahini Alfredo recipe (page 78), why not use them as the base for the Mediterranean Tilapia (page 88)? For more combinations and ideas on how to mix and match recipe components in the book, see the epilogue on the topic (page 114).

Each recipe in he first chapter has a table that lays out how each specific recipe fulfills the four pillars of a balanced bowl. This will aid you in discovering how the method of building a bowl in the introduction carries through into the recipes I am sharing with you. The tables on these recipes are intended as a representative guide to get ideas flowing. I have listed the ingredients and components that seem most relevent instead of getting too detailed, e.g. listing every source of protein in the dish.

I hope you feel empowered and inspired by the recipes you find in this book. Many additions and substitutions will work for all in all the bowls in this book. And as is the way with smorgasbowls, you should feel empowered and inspired to cook and make these recipes work for you and your family. Learning from the methods and then adapting is welcome and encouraged.

RECIPE TYPE DECODER

GF| gluten free • DF|dairy free • Paleo| paleo • Vegan|vegan

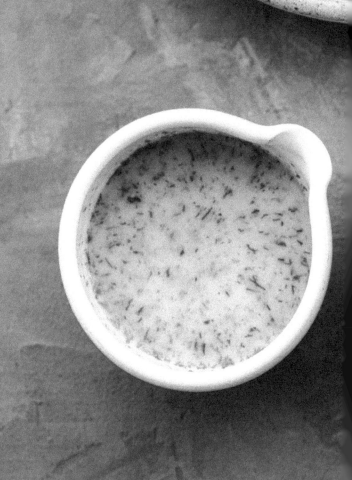

GREAT
SMORGASBOWL
EXAMPLES
(WITH PILLAR TABLES)

PAN-FRIED CABBAGE | MILLET AND ROASTED VEGGIE BOWL |
APPLE-CHICKPEA KALE SALAD | NICOISE-INSPIRED BOWL

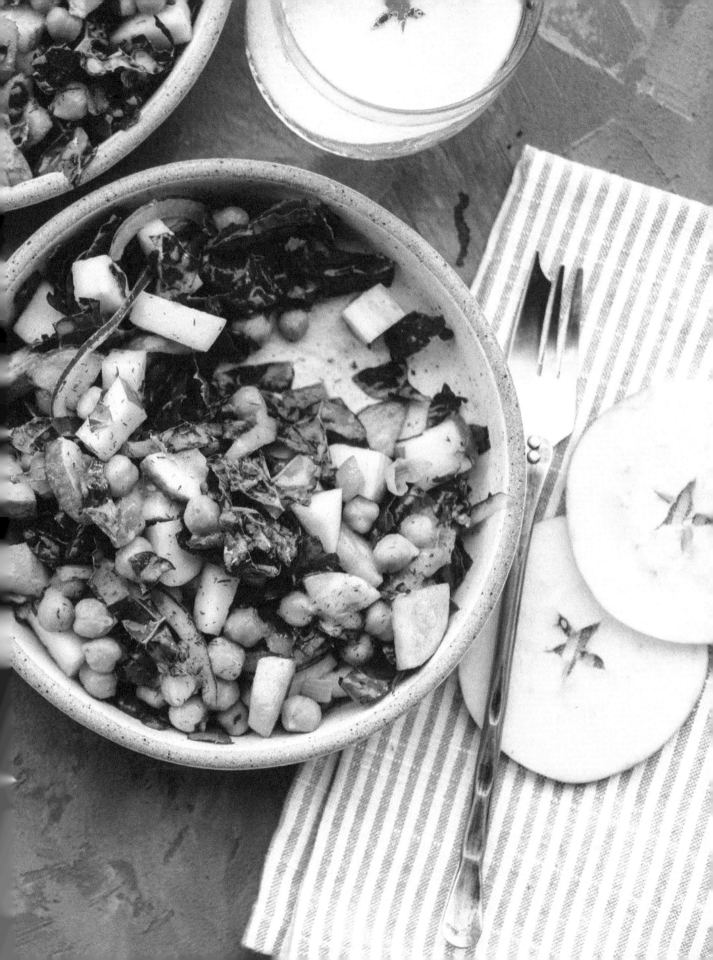

PAN FRIED CABBAGE
with lentils, red peppers and limey avocado

MAKES 4 BOWLS, PLUS EXTRA LENTIL SALAD
PLAN AHEAD: LENTIL SALAD CAN BE MADE AHEAD OF TIME AND STORED IN THE FRIDGE FOR A FEW DAYS

Browned cabbage is endlessly satisfying. I didn't expect to love baked, pan-fried and grilled cabbage as much as I do given its humble nature, but I honestly crave it. This vegan meal features pan-fried cabbage wedges and adds plant protein (lentils) and fat (avocado) to make a well-rounded bowl with tons of flavor!

Lentil salad

2 (15-16 ounce) cans of lentils, strained and rinsed

1 red bell pepper, diced small

½ small red onion, diced small

2 cloves of garlic, minced

¼ cup fresh parsley, minced (plus more for garnish)

1 teaspoon ground cumin

½ teaspoon sea salt

¾ cup olive oil

Cabbage wedges

4 tablespoons cooking oil

1 medium head of cabbage, cut into 8 large wedges

Limey avocado

1 avocado, cubed

Juice from 2 limes

Extra parsley for garnish (optional)

1. To make lentil salad, combine all ingredients in a medium-sized bowl and stir until well combined. Marinate salad for at least 10 minutes, or cover and store in the fridge overnight before serving the next day.

2. In a large heavy-bottomed skillet over medium-high heat, heat oil until hot. Evenly coat the bottom of the pan with the heated oil and then add cabbage wedges cut side down. Brown without moving the wedges for about 8 minutes. Once browned on one side, flip each wedge to its other cut side and brown on that side, which should take 4-5 minutes on the second side.

3. Combine avocado and lime juice in a small bowl, stir and set aside until you are ready to serve.

4. Once cabbage wedges are browned, serve by first placing 1-2 cabbage wedges into a bowl, then scooping 2-3 large spoonfuls of lentil salad over the wedges and finally top with a few small spoonfuls of limey avocado and spinkle with parsley (if using).

FLAVOR	TEXTURE	NUTRITION	TEMPERATURE
Acid: Lime Juice	**Crispy/crunchy:** Bell Pepper, Onion	**Protein:** Lentils	**Hot/warm:** Cabbage
Salt: Sea Salt	**Meaty:** Lentils	**Fiber:** Cabbage	**Cold:** Lentil Salad (if kept in fridge overnight)
Spicy: Red onion	**Smooth/soft:** Avocado	**Fat:** Avocado	**Room temp:** Avocado
Sweet: Bell Peppers	**Thin/thick sauce:** Olive Oil and Lime Juice	**Carb:** Lentils	
Umami: Browned Cabbage			
Bitter: Parsley			

PILLAR TABLE FOR THIS RECIPE (SEE THE FOUR PILLARS OF A BALANCED SMORGASBOWL, PAGE 4)

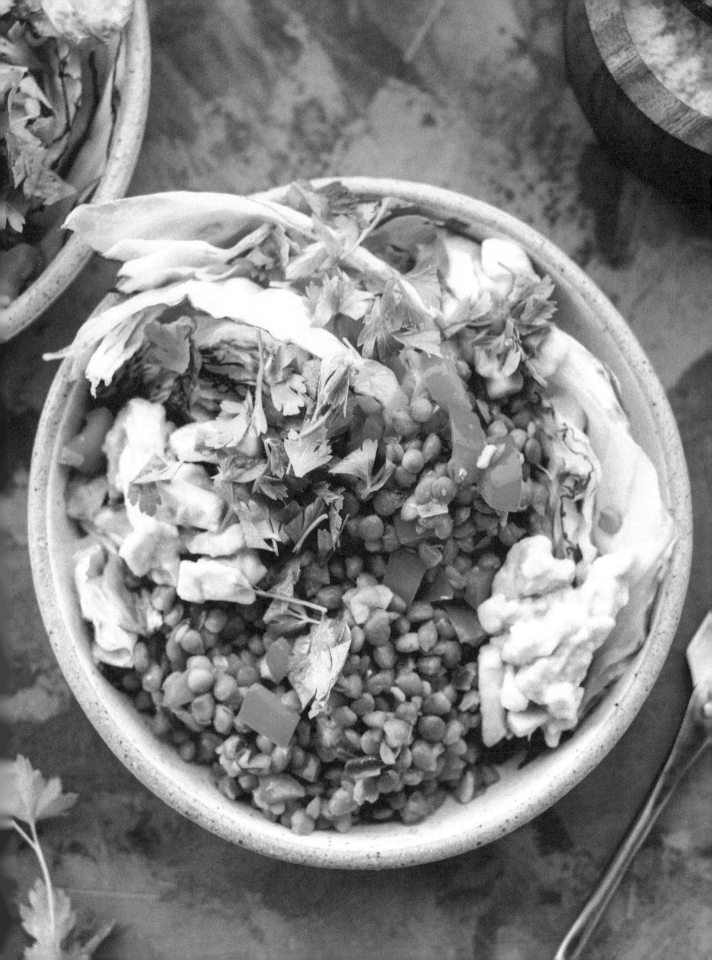

MILLET AND ROASTED VEGGIE BOWL
with anchovy-walnut dressing

 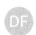

MAKES 4 BOWLS
PLAN EXTRA TIME: MILLET COOKS FOR 20 MINUTES AND ROASTING TAKES 25 MINUTES. COOKING TIMES CAN/SHOULD OVERLAP.

This recipe pulls together three of my favorite tricks for getting a delicious dinner on the table: sheet pan-roasting, a stellar dressing and zesty grains. Any one of these tricks alone will pull a bowl up from mediocre to great, but putting all three together will give you a dynamic and well-composed meal with tons of flavor.

Roasted veggies

1 red bell pepper, sliced

1 bunch asparagus, woody ends removed

1 medium fennel bulb, coarsely chopped

½ small red onion, chopped

Millet

1 cup millet, uncooked

2 tablespoons lemon juice

2 tablespoons fresh parsley, minced

½ teaspoon sea salt

Massaged Spinach

5 ounces (3-4 large handfuls)
 baby spinach, roughly chopped

2 tablespoons Olive Oil

Recipe for Anchovy-walnut dressing
(next page and page 108)

1. Preheat oven to 350°F.

2. Prepare veggies for the oven by spreading out washed and cut veggies on a large sheet pan in a single layer. For easy cleanup, you can line the pan with foil or parchment paper.

3. Put sheet pan with veggies in the pre-heated oven and roast them until soft and lightly browned, about 25 minutes. Remove sheet pan from oven and reserve until ready to serve.

4. Bring 2 cups of water to a boil in a small saucepan. Add uncooked millet and cover. Turn down to low heat and cook millet, covered, for 20 minutes, until grains are fluffy and all liquid is absorbed.

5. Once millet is cooked, remove from heat and allow it to cool for 7-10 minutes, then stir in lemon, parley and sea salt.

6. For the massaged spinach, put spinach and oil together in a bowl and massage with your hands until slightly wilted.

7. To serve, scoop about a cup of millet, about an equal portion of roasted veggies and about a handful of spinach in a bowl, dress generously with anchovy-walnut dressing, and serve immediately.

FLAVOR	TEXTURE	NUTRITION	TEMPERATURE
Acid: Vinegar & Lemon Juice	**Crispy/crunchy:** Walnuts	**Protein:** Anchovies and	**Hot/warm:** Roasted Veggies
Salt: Sea Salt	**Meaty:** Roasted Veggies	Walnuts	**Cold:** Spinach*
Spicy: Garlic	**Smooth/soft:** Millet	**Fiber:** Spinach	**Room temp:** Dressing*
Sweet: Roasted Veggies	**Thin/thick sauce:** Dressing	**Fat:** Olive Oil	*Temperature will vary with how
Umami: Anchovies		**Carb:** Millet	ingredients are stored
Bitter: Parsley			

PILLAR TABLE FOR THIS RECIPE (SEE THE FOUR PILLARS OF A BALANCED SMORGASBOWL, PAGE 4)

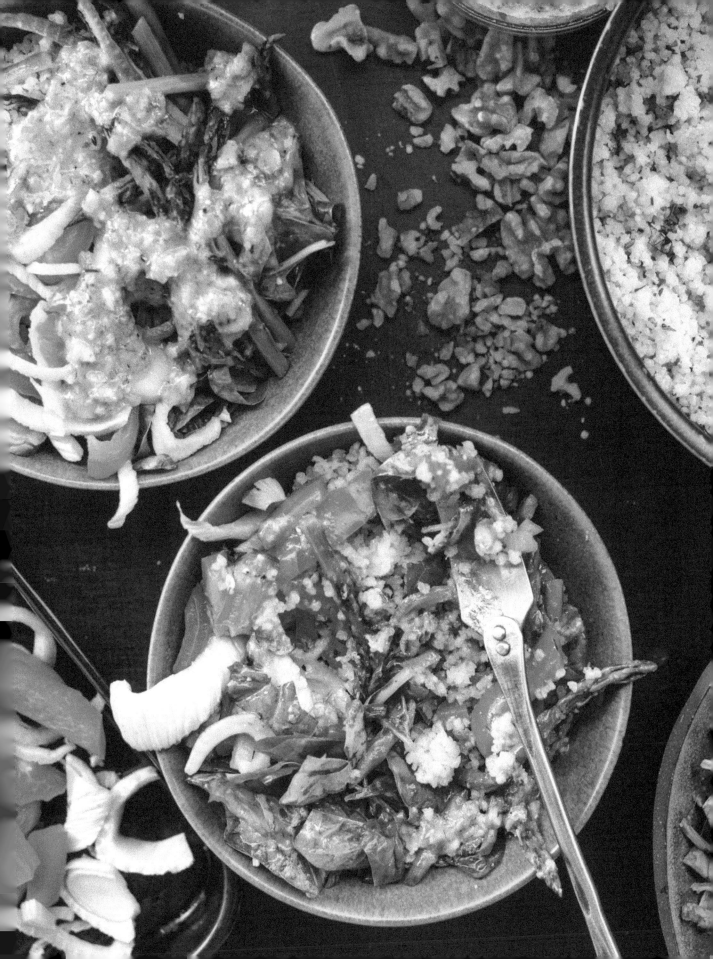

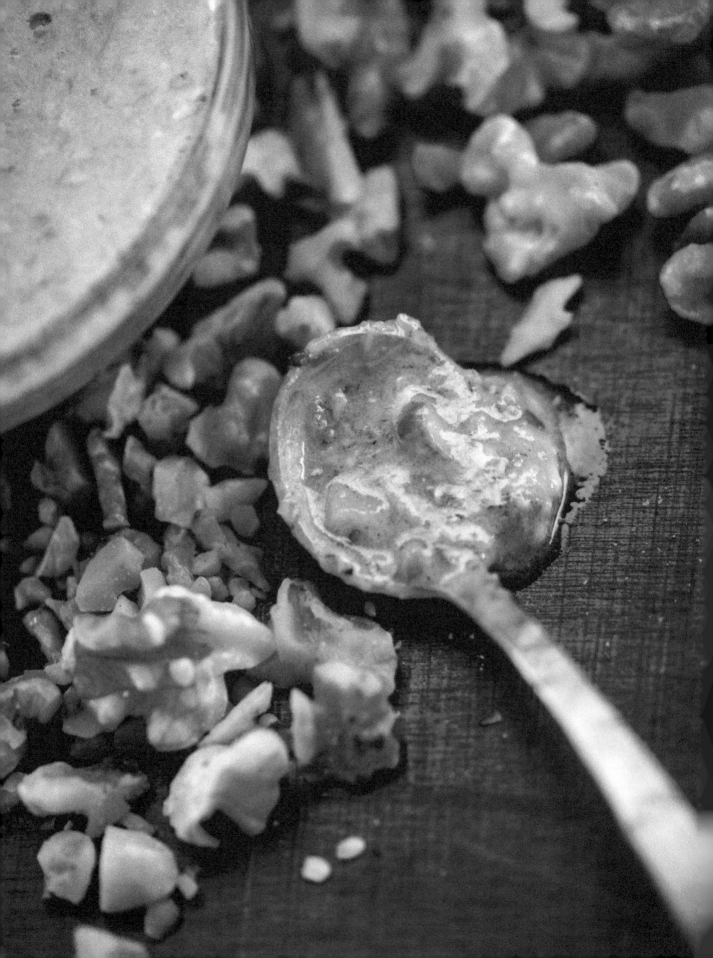

ANCHOVY-WALNUT DRESSING

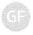

MAKES 1 CUP
SPECIAL EQUIPMENT: HIGH-SPEED BLENDER
PLAN AHEAD: DRESSING CAN BE MADE THE DAY AHEAD AND STORED IN THE FRIDGE

Make dressing by combining anchovies, garlic and next four ingredients into a high-speed blender and blend until well combined, about 30 seconds. Remove from the blender and stir in chopped walnuts and dill.

10 anchovies, canned or packed fresh

4 small garlic cloves

2 teaspoons apple cider vinegar

4 tablespoons fresh lemon juice

½ cup olive oil

2 teaspoons coconut aminos

2 tablespoons fresh dill, minced

½ cup walnuts, chopped

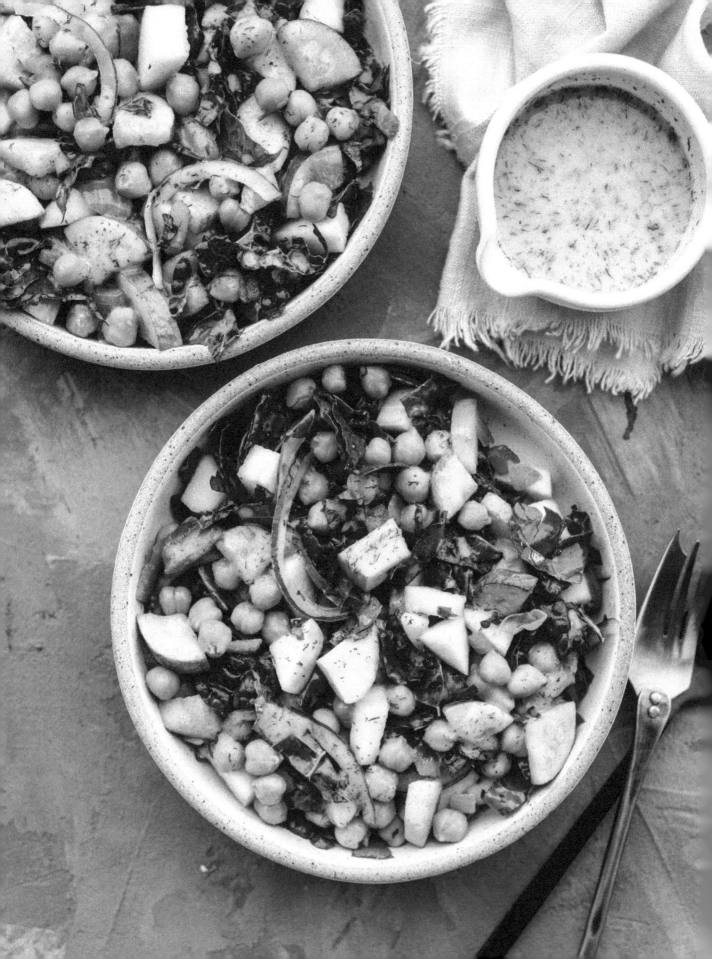

APPLE-CHICKPEA KALE SALAD
with orange-mustard-dill dressing

MAKES 4 BOWLS

This recipe is a delight of contrasting textures, temperatures and flavors. Yes, this is a salad, but it isn't your choke-down-your-raw-veggies kind of salad. It is the kind of salad that has warm *and* cold veggies, crunchy apples, meaty chickpeas, the slight tingle of a thinly sliced red onion, and more to keep you interested in what your next bite combination will be. A better name is required for a salad like this — come to think of it, it's a smorgasbowl!

1. Heat two tablespoons of butter or cooking oil in a sauté pan over medium-high heat until hot, then add the zucchini and onions. Cook zucchini and onions in the pan, stirring with a spatula, until zucchini and onions are softer and lightly browned, about 6 minutes.

2. Add strained and rinsed chickpeas to the pan with the zucchini and onions and sauté over medium-high heat until chickpeas are heated through, about 2 minutes. Once done, remove from heat and set aside.

3. Massage the kale in a large bowl by first coating the kale with the olive oil, sprinkling with the sea salt, and then squeezing the kale firmly in your hands until all of the kale has lost some water and wilted considerably. Add the apples and red onion into the bowl with the kale and toss together.

4. Make the dressing by adding all of the ingredients to a small glass jar with a lid and shaking until well combined.

5. To serve, arrange equal portions of kale salad and warm zucchini, onions and chickpeas in bowls. Drizzle with dressing and enjoy!

Salad

2 tablespoons butter or cooking oil

2 small zucchini, diced

½ small yellow onion, diced

1 (15-16 ounce) can of chickpeas, strained and rinsed

1 bunch Tuscan kale, large stems removed and chopped fine

1 tablespoon olive oil

½ teaspoon sea salt

1 medium honeycrisp or similar apple, diced

½ small red onion, sliced thin

Dressing

¼ cup orange juice

1 tablespoon lemon juice

¼ cup olive oil

2 tablespoons mustard

1 teaspoon dried dill

FLAVOR	TEXTURE	NUTRITION	TEMPERATURE
Acid: Orange & Lemon Juice **Salt:** Sea Salt **Spicy:** Mustard & raw onion **Sweet:** Apples **Umami:** Chickpeas **Bitter:** Kale	**Crispy/crunchy:** Apple **Meaty:** Chickpeas **Smooth/soft:** Zucchini & Onion **Thin/thick sauce:** Dressing	**Protein:** Chickpeas **Fiber:** Kale, Apple **Fat:** Olive Oil **Carb:** Chickpeas	**Hot/warm:** Zucchini, onions & chickpeas **Cold:** Dressing **Room temp:** Apple, kale

PILLAR TABLE FOR THIS RECIPE (SEE THE FOUR PILLARS OF A BALANCED SMORGASBOWL, PAGE 4)

NICOISE-INSPIRED BOWL
with tuna and mustard dressing

MAKES 2 DINNER BOWLS

The Nicoise salad is a combination of ingredients that leaves me wondering what it really takes to call something a salad. It's really a collection of stand-alone stars that join together in any and every combination to create perfect bites. This is why it has become a classic dish and easily lends itself to the smorgasbowl. The components stand alongside each other, tasting great on their own but also playing well together no matter how you fork it. You'll steam, boil and cut fresh veggies for this one and keep it simple with canned tuna. The mustard dressing with zingy fresh shallots will finish it off.

2 eggs, hard or soft boiled with shell removed and sliced in half

1 pound small red potatoes, diced

2 teaspoons sea salt

1 bunch (5-6) radishes

12 ounces green beans, ends trimmed

½ english cucumber, sliced diagonally

1 (5-ounce) can of your favorite tuna

½ cup your favorite olives, pitted and cut in half

Fresh dill to garnish (optional)

Freshly cracked black pepper (optional)

Dressing

3 tablespoons lemon juice

2 tablespoons dijon mustard

¼ cup olive oil

1 small shallot, diced fine

½ teaspoon sea salt

1. To hard or soft cook the eggs, fill a small saucepan with about 6 cups of water and bring to a boil over high heat on the stove. Lower eggs into the pan on a spoon so they don't crack, and cook at a boil to desired doneness (7 minutes for a soft boil, 14 minutes for a hard boil).

2. Fill a medium saucepan lined with a steamer insert with water below the line of the insert. Remove insert. Bring water to a boil and add diced potatoes and sea salt to the bottom of the pot.

3. Take advantage of the steam coming off of the potatoes to cook your beans and radishes. Place the steamer insert back into the pot and put the green beans and radishes into the steamer insert and cover. Steam beans and radishes for 7-8 minutes, then remove the steamer basket from the heat and set aside until you are ready to serve. Leave the potatoes covered in the saucepan and continue to boil. Potatoes will take 12-14 minutes total to get soft.

4. Once potatoes are tender when pierced with a fork, remove from heat and strain.

5. To make the dressing, add all the ingredients to a small jar with a lid and shake until mixture is well combined.

6. To serve, arrange potatoes, green beans, radishes, cucumber and tuna into bowls. Drizzle with the dressing, and then top with olives, fresh dill (if using), cracked pepper (if using) and the hard- or soft-boiled egg.

FLAVOR	TEXTURE	NUTRITION	TEMPERATURE
Acid: Lemon Juice	**Crispy/crunchy:** Green beans, radish	**Protein:** Tuna, eggs	**Hot/warm:** Potatoes
Salt: Sea Salt	**Meaty:** Tuna	**Fiber:** Green beans, cucumbers	**Cold:** Cucumber
Spicy: Mustard & shallot	**Smooth/soft:** Potatoes	**Fat:** Olive Oil	**Room temp:** Tuna
Sweet: Green beans	**Thin/thick sauce:** Dressing	**Carb:** Potatoes	
Umami: Tuna			
Bitter: Olives, radishes			

PILLAR TABLE FOR THIS RECIPE (SEE THE FOUR PILLARS OF A BALANCED SMORGASBOWL, PAGE 4)

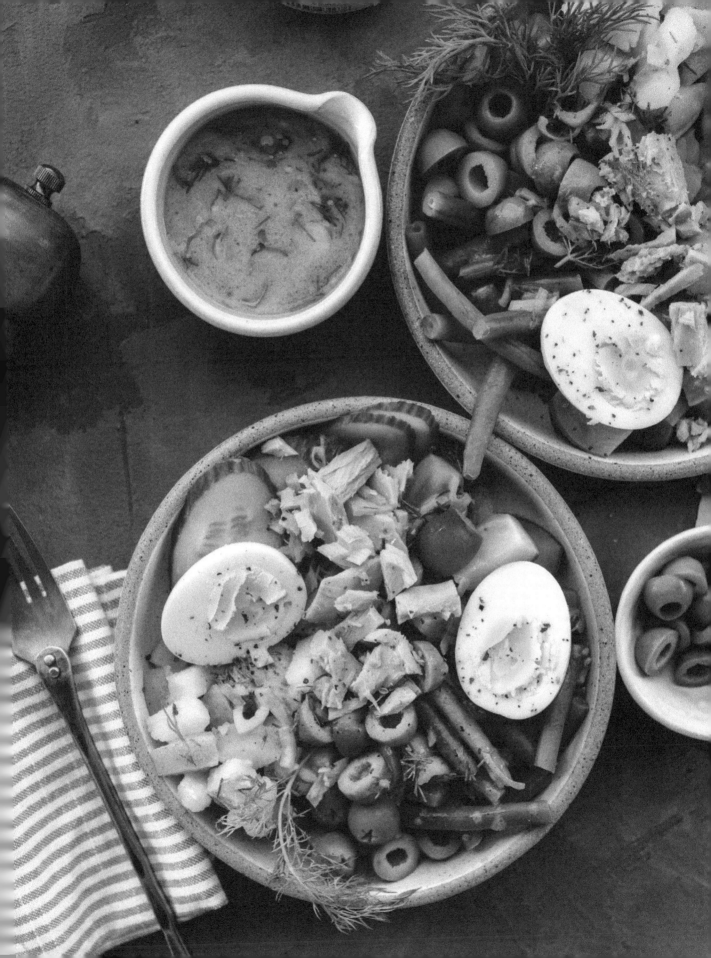

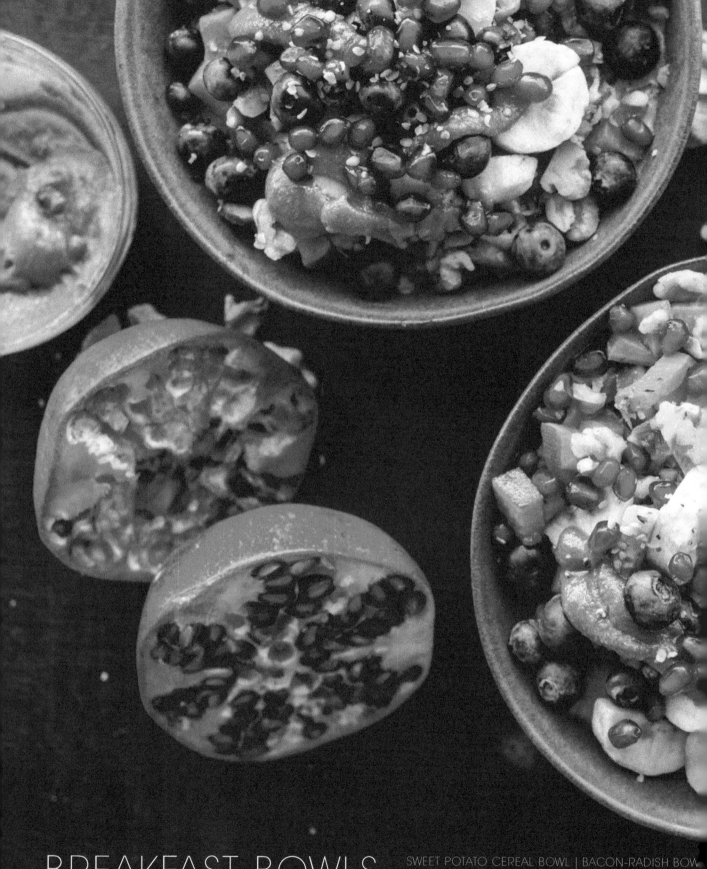

BREAKFAST BOWLS

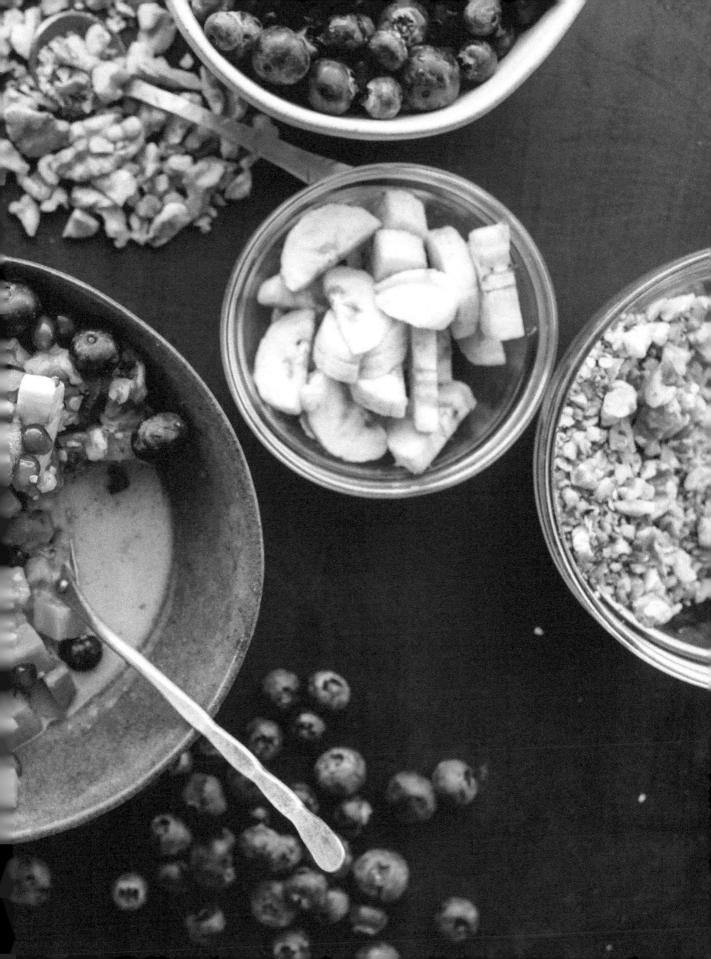

SWEET POTATO CEREAL BOWL
with walnuts, hemp seeds and fruit

MAKES 4 BOWLS

When you go grain free, you are basically telling the world you won't be eating cereal anymore; save a few granolas out there. You're resigning to eating something else out of your breakfast bowl. Here's a cereal bowl that's gotten a major upgrade. This bowl is rich with warm sweet potatoes, crunchy from toasted nuts and seeds, and it pops sweet and fresh with pomegranates and blueberries. Best of all though, it won't send you on a sugar high that has you crashing back to earth shortly after eating. Instead, you'll be fully satisfied and get cereal back!

Sweet potatoes

4 tablespoons butter, ghee or cooking oil of choice (use cooking oil for vegan)

2 medium sweet potatoes, diced

For the bowl

1 cup walnuts, coarsely chopped

4 tablespoons hemp seeds

1 pint blueberries

1 banana

½ cup pomegranate seeds

1-2 cups milk of choice for serving (see note below)

Tahini-date sauce

2 tablespoons tahini

1 tablespoon date syrup

1. Heat butter, ghee or oil in a medium saute pan over medium-high heat. Once butter melts or oil is hot, add diced sweet potatoes and cook until sweet potatoes start to soften and brown, about 5 minutes. Pour 2 cups of water over the sweet potatoes and bring to a simmer. Cook sweet potatoes at a simmer for 12-14 minutes until most of the liquid is absorbed or cooked off and sweet potatoes are soft.

2. While sweet potatoes are cooking, toast walnuts by adding them to a dry sauté pan and heating over medium high heat for about 7 minutes, tossing and stirring regularly. Once toasted, place in a bowl and stir in hemp seeds.

3. Slice banana and remove pomegranate seeds from flesh (cut along the equator of the fruit and hit the rind with a wooden spoon to release seeds into a bowl).

4. Vigorously stir tahini and date syrup together in a small bowl to make sauce.

5. To build your bowl, add prepared ingredients in this order: sweet potatoes, walnuts and hemp seeds, blueberries, banana, tahini-date sauce and pomegranate seeds. Pour milk of your choice over top and serve immediately.

MILK If you have yet to find a milk alternative on market shelves that suits you, try making a milk alternative at home. Tahini and hemp milk are quick options because they don't require soaking. Just combine 1 cup of hemp seeds or ½ cup of tahini with 4 cups of water and blend in a high-speed blender until no large bits remain. Use straight from the blender, or strain if you don't want any graininess. Seal any extra in a container and store in the fridge for up to a week.

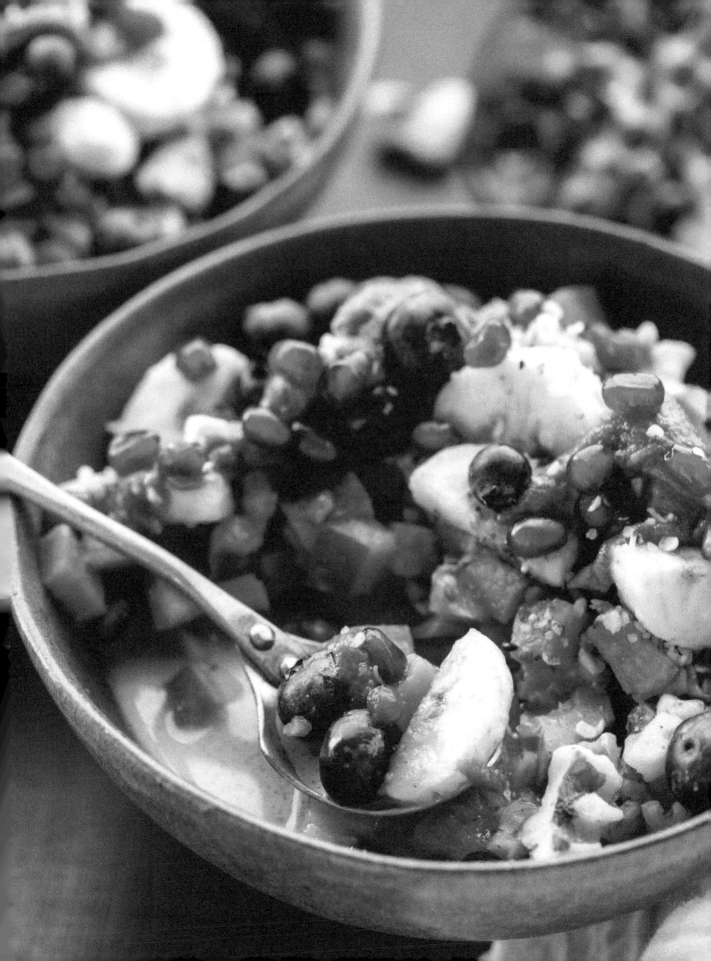

BACON-RADISH BOWL
with avocado, spinach and herby pepita dressing

MAKES 2 BOWLS

I don't know about you, but the less I have to think about breakfast the better. I realize this may seem like a contradiction as this recipe requires you to make both bacon and a dressing. So here is how to make this recipe work for breakfast: make the dressing ahead and store in the fridge (this dressing is the same as the Mexi-bowl!) and figure out a time during the week to make some extra bacon to store in the fridge. When I make this recipe for breakfast, the bacon isn't always freshly made, and the dressing *never* is. So when breakfast time comes, all you have to do is pull components out of the fridge, slice the radish, wilt the spinach and scoop an avocado. You got this!

1 (12-ounce) pack of sugar-free bacon

5 ounces baby spinach

4 small red radishes, sliced thin

2 small watermelon radishes, sliced thin

1 avocado, sliced

Recipe for Herby Pepita Dressing (next page and page 102)

1. To make the bacon, heat a medium skillet over medium-high heat until hot. Then remove all of the bacon from the package and cut the bacon into small sections with kitchen scissors over the heated pan. Once all the bacon is cut and in the pan, break sliced bacon pieces apart with a spatula. Cook bacon on medium high heat, turning often, until fat is rendered and bacon is crisp, 10-12 minutes.

2. Once bacon is cooked, carefully remove from pan, straining bacon from liquid fat by pulling it away with a spatula and place it onto a plate lined with paper towels to soak up any remaining fat from the bacon. Bacon will continue to crisp as it cools. Let rest while you prepare everything else.

3. Prepare a new pan with 2 tablespoons of leftover bacon fat. Heat pan and bacon fat to medium high heat and add spinach. Cook for about a minute, moving it around the pan a lot with a spatula until all spinach is wilted.

4. To prepare bowl, arrange spinach, sliced radishes, sliced avocado and bacon in a bowl. Then top with about a fourth cup of dressing and serve immediately.

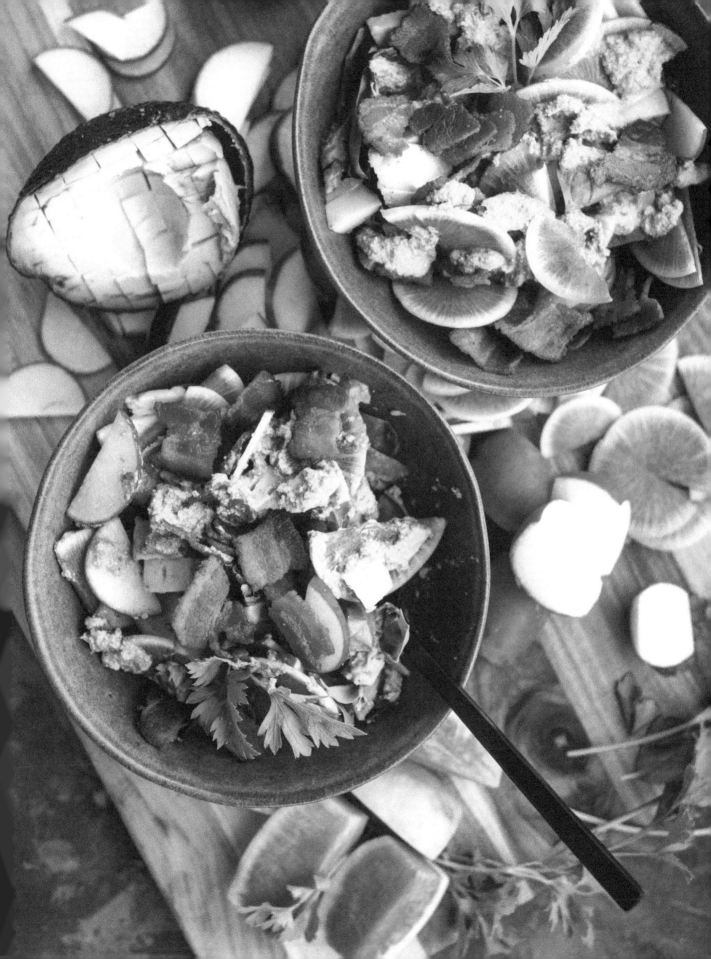

HERBY PEPITA DRESSING

MAKES 4 CUPS
SPECIAL EQUIPMENT: HIGH-SPEED BLENDER

1 large bunch of cilantro, large stems
removed (about 4 cups)

1 cup parsley, large stems removed

2 cups pepitas, toasted (see toasting
nuts and seeds, page 55)

½ teaspoon sea salt

4 tablespoons lime juice

2 cups water

To prepare sauce, combine all ingredients into a high-speed blender and blend until very smooth. Can be made ahead of time and stored in the fridge for a week.

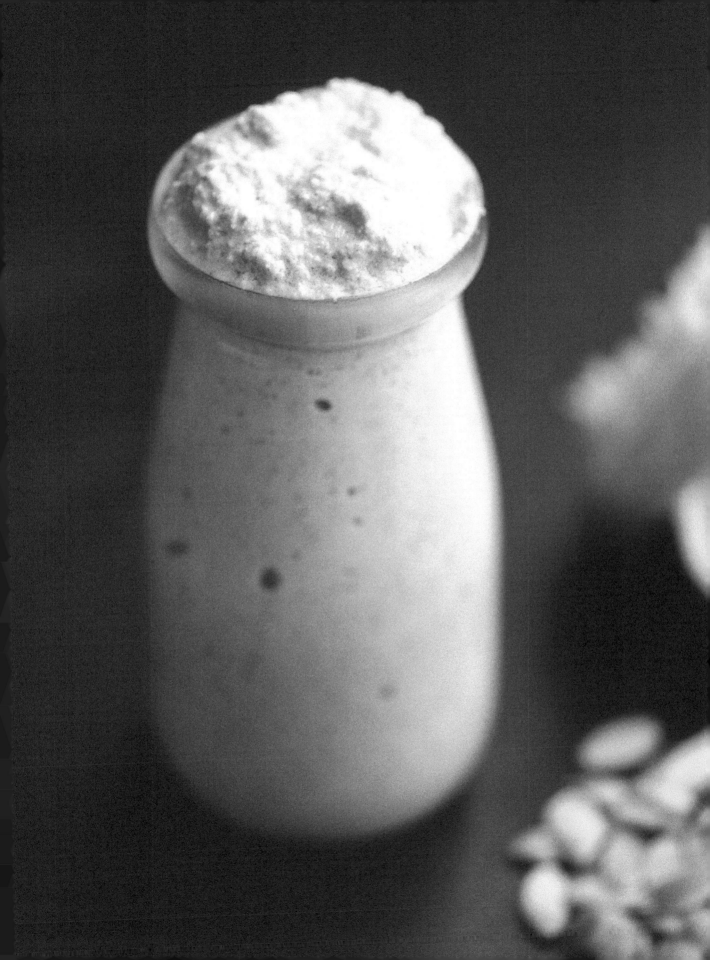

EGG, ZUCCHINI AND CORN HASH
with fresh tomato mixture

MAKES 3 BOWLS

Growing up in Colorado, I have fond memories of the vine-ripened cherry tomatoes and sweet corn that would roll into the markets around August every year. Around that same time my grandma would be pulling zucchini the size of baseball bats out of the garden and there were never enough ways to eat summer squash. This recipe is one of those simple celebrations of seasonal produce at its peak. Don't make this with the watery, flavorless cherry tomatoes you find in the grocery store in the middle of January, wait for the good stuff.

NOTE: This recipe uses one pint of cherry tomatoes, half are for the tomato mixture and the other half are cooked with the other veggies and eggs.

Fresh tomato mixture

½ pint cherry tomatoes, sliced in half

½ cup basil leaves, minced

1 tablespoon lime juice

2 tablespoons olive oil

1 garlic clove, smashed or minced

½ teaspoon sea salt

Hash

4 tablespoons olive oil, for the pan, divided

2 medium zucchini, diced

½ medium yellow onion, diced

½ teaspoon sea salt

½ pint cherry tomatoes

1 ear of raw corn, kernels cut from the cob

5 ounces spinach, roughly chopped

6 eggs, whisked or beaten with a fork

1. Combine all ingredients for the fresh tomato mixture in a small bowl and set aside to let marinate for 10-15 minutes.

2. Heat two tablespoons of the olive oil in a large sauté pan over medium-high heat until hot then add zucchini and onion and sprinkle with the sea salt. Cook zucchini and onion for 6 minutes, stirring them occasionally in the pan with a spatula.

3. Add the remaining ½ pint of tomatoes to the pan and sauté for another 5 minutes.

4. Add corn and spinach to the pan with the zucchini, onions and tomatoes and cook for another 2-3 minutes.

5. Turn heat to low and move veggies to one side of the pan. Add the remaining 2 tablespoons of olive oil to the exposed part of the pan then pour the whisked eggs over the olive oil you just added to the pan.

6. Scramble eggs by scraping the cooked portion away from the bottom of the pan with a spatula every second or two and keeping the eggs moving until slightly cooked, careful to not get too much up the sides of the pan. Then start folding them into the veggies and turning over the veggie and egg mixture until all of it is cooked through, 2-4 minutes.

7. To serve, first put heated egg and veggie hash into a bowl, and then top with the fresh tomato mixture.

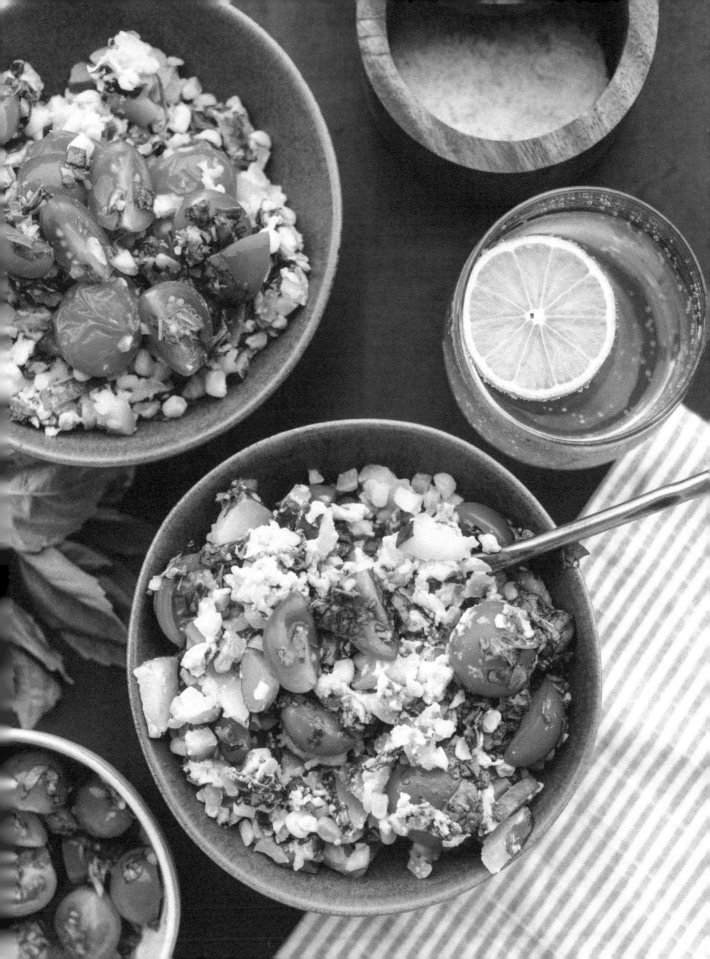

BANANA-TAHINI CHIA PUDDING
with peanut butter chocolate sauce

MAKES 6 SMALL SERVINGS
SPECIAL EQUIPMENT: HIGH-SPEED BLENDER
PLAN EXTRA TIME: CHIA PUDDING NEEDS TO THICKEN THE FRIDGE FOR AT LEAST 4 HOURS

Where is the line between breakfast and dessert anyway? Basically they can be one and the same. This chia pudding won't disappoint your sweet tooth, but also packs seeds and nuts to keep a sugar crash at bay. Let's be clear about one thing though — you're not going to be mad when you wake up with this chia pudding waiting for you in the fridge.

Pudding

5 tablespoons tahini

2 cups water

1 banana

1 tablespoon vanilla

3 pitted dates

¼ teaspoon sea salt

¾ cup chia seeds

Peanut Butter Chocolate Sauce

½ cup peanut butter (smooth or chunky, just peanuts in the ingredient list)

½ cup chocolate chips

Garnish

Unsweetened coconut flakes

Strawberries, raspberries, blueberries and/or blackberries

1. Combine tahini, water, banana, vanilla, dates and sea salt in a high speed blender (don't make the mistake of adding the chia seeds to the blender, wait to add them until after you've removed the pudding base from the blender) and blend on high until very smooth, about 30 seconds.

2. Pour pudding base into a jar or container with a lid and add the chia seeds. Put on the lid and shake. Place pudding in the refrigerator and let the chia seeds expand for at least 4 hours, shaking once or twice during that time.

3. After the pudding has chilled and chia seeds are hydrated, make the chocolate peanut butter sauce by combining the chocolate chips and peanut butter in a small saucepan. Heat over medium-low heat until chocolate is melted, stirring often (chocolate can burn quickly!). Once chocolate is melted and fully incorporated with the peanut butter, remove from heat and set aside for serving.

4. To serve, add chia pudding to a small bowl and top with the chocolate peanut butter sauce. Garnish with a sprinkle of coconut flakes and a handful of your favorite berries.

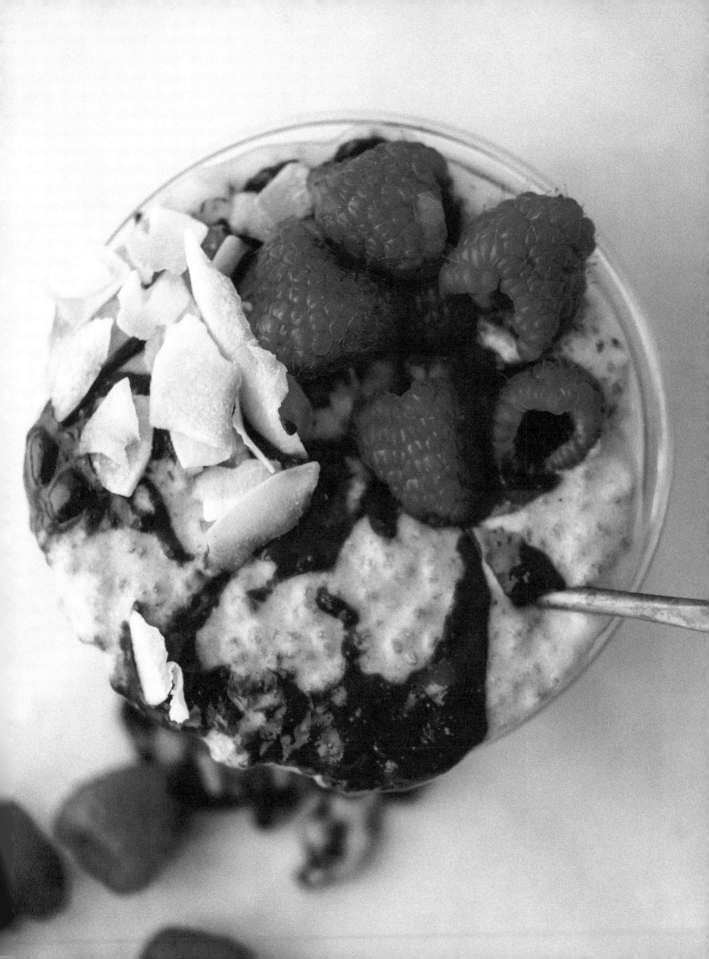

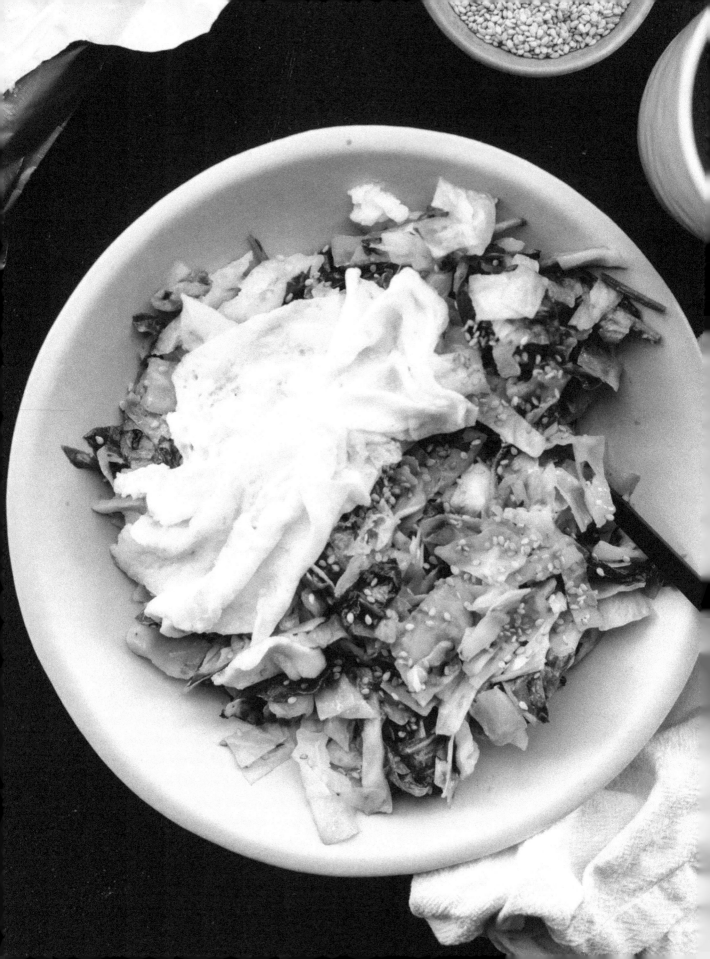

SPINACH AND CABBAGE BREAKFAST
with egg whites

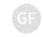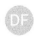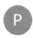

MAKES 1 LARGE BREAKFAST BOWL, OR TWO SMALLER BOWLS

One of the best ways to start the day out right is to include veggies in your breakfast. Veggies in the morning aren't always something that's easy to look forward to, but this bowl is crave-able because the cabbage and spinach are pan-fried until they are silky and browned so they pair perfectly with the eggs. The dish is finished with lemon, my beloved tahini and the oh-so-versatile toasted sesame seed. For those who can tolerate egg yolks, there is no reason not to fry the whole egg.

1. Heat butter or cooking oil in a medium sauté pan over medium-high heat until melted, then add diced green cabbage and spread over the entire surface of the pan. Leave alone and allow to cook and brown for about 4 minutes, then turn over cabbage and let it cook on the other side for 3-4 more minutes.

2. Add chopped spinach to the cabbage in the pan and saute until spinach wilts, about 1 minute.

3. Drizzle tahini, lemon juice and sea salt evenly over the cabbage and spinach in the pan, stir to incorporate before transferring to bowl(s).

4. Make sure your pan is mostly cleaned out (tahini bits can burn if there are any remaining) and separate the egg whites from the egg yolk. Discard egg yolks or reserve them for another use. Add the other tablespoon of butter or oil to your sauté pan over medium-high heat and wait for it to heat up.

5. Cook egg white on one side without scrambling for about 30 seconds, then flip the whites over and cook about 20 seconds on the other side before sliding the egg whites from the pan and into the bowl over the cabbage and spinach. Sprinkle toasted sesame seeds on top and serve.

Cabbage and spinach

2 tablespoons butter or cooking oil for the pan

½ small head (3-4 cups) of green cabbage, diced (see note)

5 ounces (3-4 large handfuls) baby spinach, roughly chopped

1 tablespoon tahini

2 tablespoons lemon juice

pinch of sea salt

Egg whites

1 tablespoon butter or cooking oil (for cooking eggs)

1-2 egg whites

¼ cup toasted sesame seeds, for serving (see toasting nuts and seeds page 55)

DICING CABBAGE To dice cabbage, cut the cabbage in half through the core, slice perpendicular strips toward the core, keeping the core intact, then rotate the cabbage 90 degrees and chop off small squares.

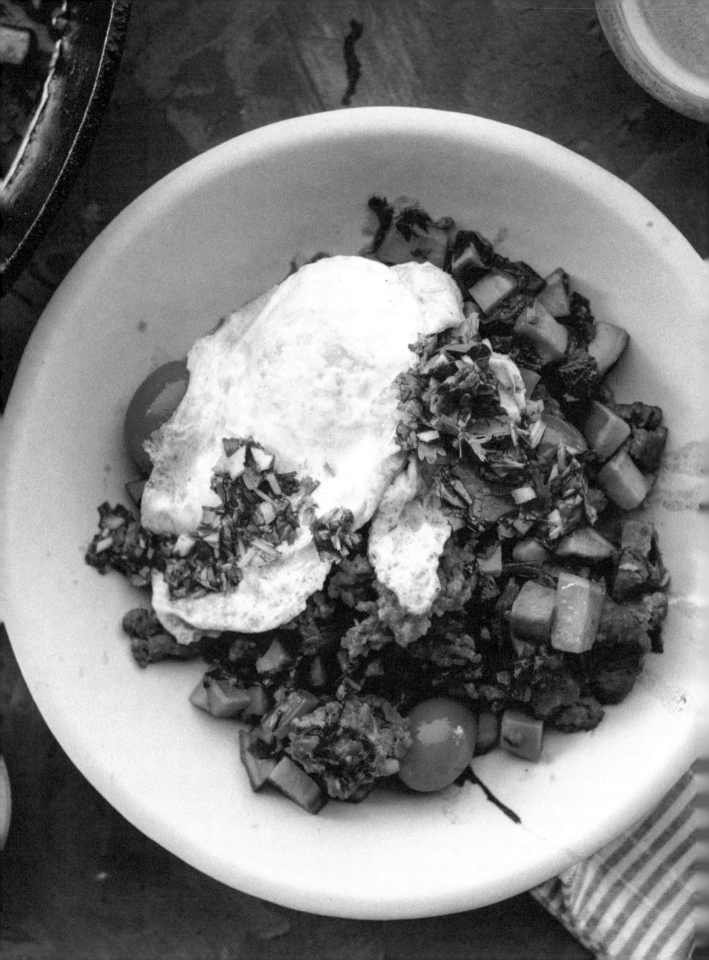

CHORIZO SKILLET
with sweet potatoes and blistered cherry tomatoes

MAKES 4 BOWLS

Love or hate cast iron skillets because of the special effort needed to maintain the seasoning, it is undeniable that they can create some of the best browning flavor for food. This recipe cooks sweet potatoes and chorizo together with veggie broth to create a complex combination of flavors. Adding the cherry tomatoes at the last minute will inject the perfect, blistered pop to this hearty breakfast.

1. Smash the garlic with sea salt by sprinkling the sea salt over the garlic and then smashing the garlic with the flat side of your knife, mincing and smashing again until you form a paste. Add smashed garlic with sea salt to the lime juice in a small bowl and set aside to marinate for at least 10 minutes.

2. Heat a heavy bottomed cast iron skillet over medium-high heat until hot. Add the pork chorizo and break apart with a spatula until it is in small chunks and covers as much of the bottom of the pan as possible. Brown on one side for 4-5 minutes, and then flip over the meat with a spatula and brown on the other side until cooked through, another 3-4 minutes.

3. Add the diced sweet potatoes to the pan and mix them in with the meat. Then add vegetable broth and stir potatoes around to make sure most are not sticking up out of the broth, giving them a pat down into the liquid if they are. Add cherry tomatoes to the pan and stir them around a bit. Bring liquid to a simmer, then turn down to low heat and cook for 12 minutes, until sweet potatoes are soft and tomatoes are blistered.

4. Cook your eggs over easy by breaking them into a pan with a little butter or oil over medium-high heat and cooking them on one side for about 1 minute, and on the other for about 30 seconds. This should set the whites, but leave the yolk runny.

5. To serve, scoop chorizo, sweet potato and tomato hash into bowls, put your eggs on top then drizzle with limey smashed garlic and sprinkle with minced cilantro.

Limey smashed garlic

1 clove of garlic

1 teaspoon sea salt

Juice from ½ a lime

Chorizo and sweet potatoes

1 pound sugar-free pork chorizo

2 medium sweet potatoes, diced

1 cup vegetable broth

1 pint cherry tomatoes

4 eggs

Oil or butter for cooking eggs

2 tablespoons fresh cilantro, minced

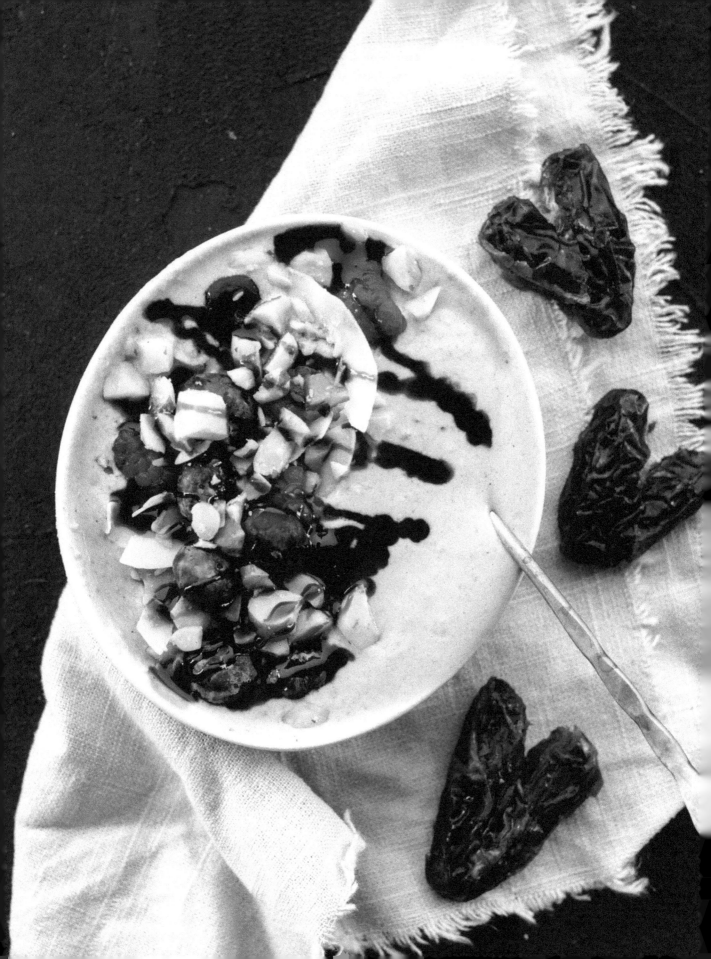

EPIC BREAKFAST SMOOTHIE BOWL
with tahini, coffee, buckwheat and coconut

MAKES 4 SERVINGS
SPECIAL EQUIPMENT: HIGH-SPEED BLENDER
PLAN EXTRA TIME: CASHEWS AND BUCKWHEAT GROATS NEED TO SOAK 6-12 HOURS

I like smoothies that are hardy, and if it's going to be my entire breakfast, it better have plenty of protein, fat and calories to prevent me from becoming a hangry monster by lunchtime. This smoothie has plenty to keep you going, including your morning kick of caffeine. The toppings give you the opportunity to personalize this smoothie to your own taste and preferences.

1. Combine all smoothie ingredients into a high-speed blender and blend until very smooth, about 30 seconds.

2. Pour smoothie into a small or medium bowl and generously add toppings of your choice.

Smoothie

1 cup raw cashews, soaked 6-12 hours in water, then strained

1 cup buckwheat groats, soaked 6-12 hours in water, then strained (can be soaked with cashews)

1 cup unsweetened coconut flakes

1 cup brewed coffee (hot or cold is fine)

2 cups ice

3 tablespoons tahini

5-6 dates, pitted

Toppings

Your favorite berries

Brazil nuts, chopped and toasted (see toasting info, opposite)

Date syrup

Unsweetened coconut flakes

Pepita

TOASTING NUTS AND SEEDS To toast nuts or seeds, heat a skillet over medium-high heat until hot. Add nuts or seeds and heat them on the pan, flipping frequently, for about 7 minutes. At this point, nuts and seeds will start to turn golden-brown. Pepitas (in other recipes, directed here) will start to pop. Remove from heat and allow seeds to cool slightly before using. Caution: dry toasting can quickly lead to a smoking, damaged pan if left unattended.

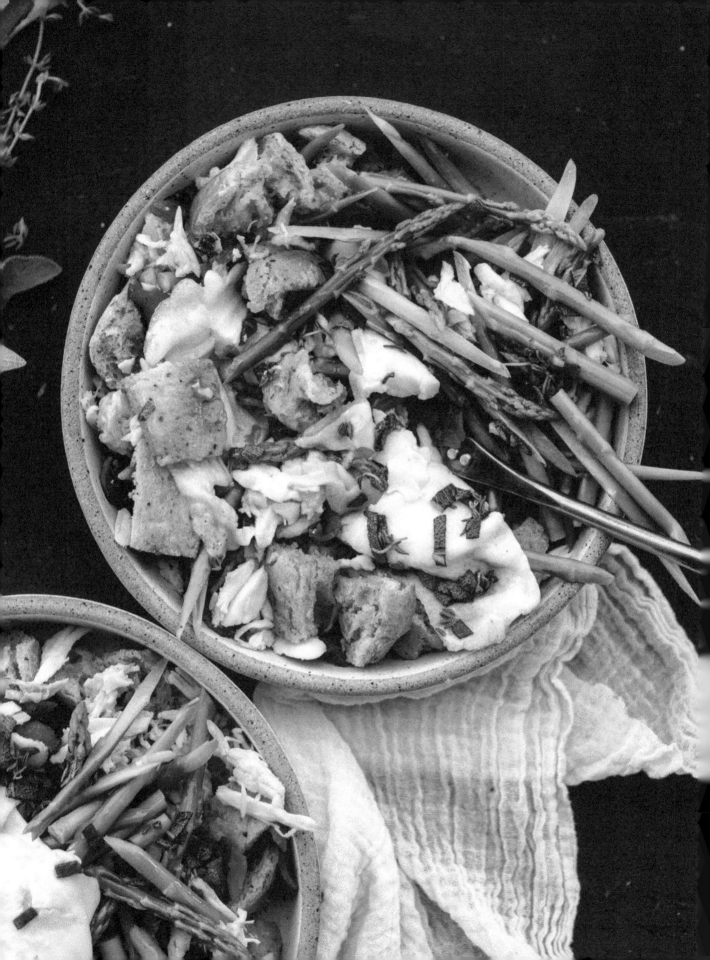

CRAB, BACON AND ROLL BOWL
with asparagus and herbed butter

GF

MAKES 2 LARGE BOWLS, PLUS EXTRA GHEE

My husband made me a version of this breakfast bowl after eating crab legs the night before and having leftovers (seems impossible … but it happened!). He said when he was a kid his favorite thing to eat for breakfast was bacon, bread and egg chopped together in a bowl. I guess his former self was preparing for the day when he would marry a smorgasbowl creator. I quickly fell in love with the dish after he made it for me with our leftover crab legs, so I'm sharing this version that elevates the concept with steamed asparagus and buttery herbage.

1. To make herb butter/ghee, melt butter (or ghee) in a small saucepan over medium-low heat. Add sage and thyme and keep on low heat for 10-12 minutes, infusing the butter with herb flavor. Remove the ghee from the heat and let rest in the pan until ready to use.

2. To cook bacon, cut it into small 1-inch-square sections and put into sauté pan or skillet heated to medium-high heat. Break pieces apart with a spatula and brown over medium-high heat, turning over frequently until bacon is browned and crisp on both sides, 8-10 minutes. Line a plate with paper towels and lift or scrape bacon onto the paper towels, careful to separate from liquid fat. Let the bacon cool on the paper towels to crisp further.

3. Steam asparagus by bringing water to a boil in a pot that has a steamer insert, but keep the steamer insert out until water is boiling. Place asparagus in the steamer insert (chop in half if they don't fit), and once water is boiling, place the steamer insert with the asparagus into the pot and cover for about 5 minutes until asparagus is slightly tender, but still a bit crunchy.

4. Toast rolls using your favorite method for making toast: sliced and put into the slots of your toaster, in your toaster oven or even a minute or two under the oven broiler. Then cut or tear rolls into roughly 1-inch cubes.

5. Cook eggs over easy by breaking them into a pan greased with a tablespoon of butter or oil over medium-high heat and cooking them on one side for about 1 minute, and on the other for about 30 seconds. This should set the whites, but leave the yolk runny.

6. To serve, layer cut rolls, crabmeat, bacon and asparagus in your bowls. Then top with the egg and drizzle generously with the herb butter.

Herb butter/ghee

½ cup butter or ghee

1 tablespoon fresh sage, minced

1 tablespoon, fresh thyme, minced

For the bowl

1 (12-ounce) pack of sugar-free bacon

1 bunch (8-10 stalks) asparagus, woody ends removed

2 (2-ounce) premade gluten-free rolls

2 eggs

1 tablespoon oil or butter for cooking eggs

4-6 ounces lump crab meat, cooked and ready to eat

SOUP AND SALAD

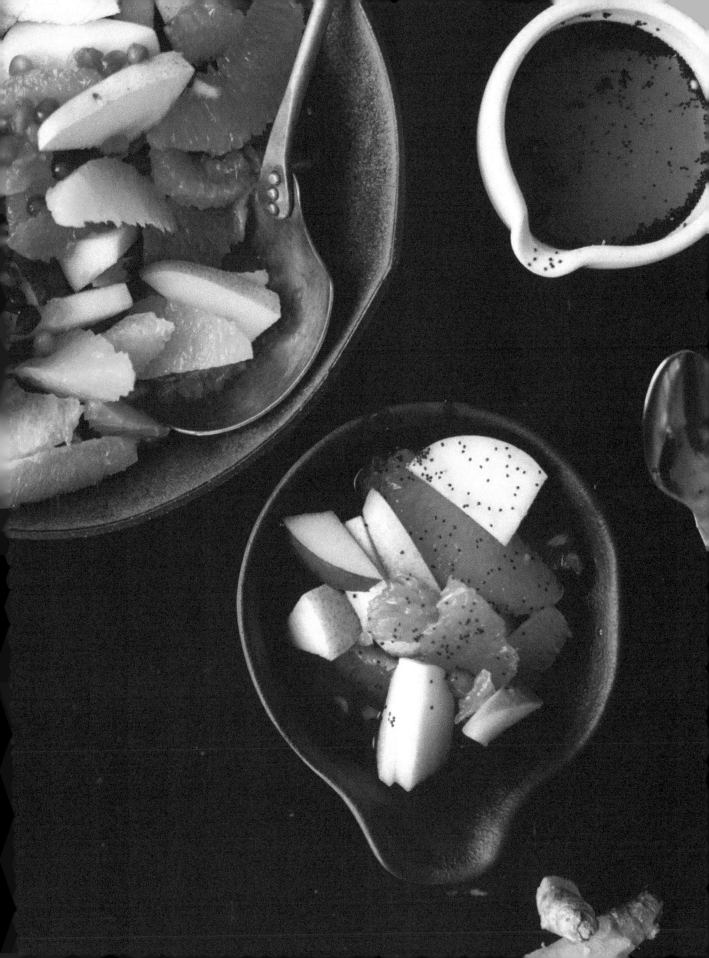

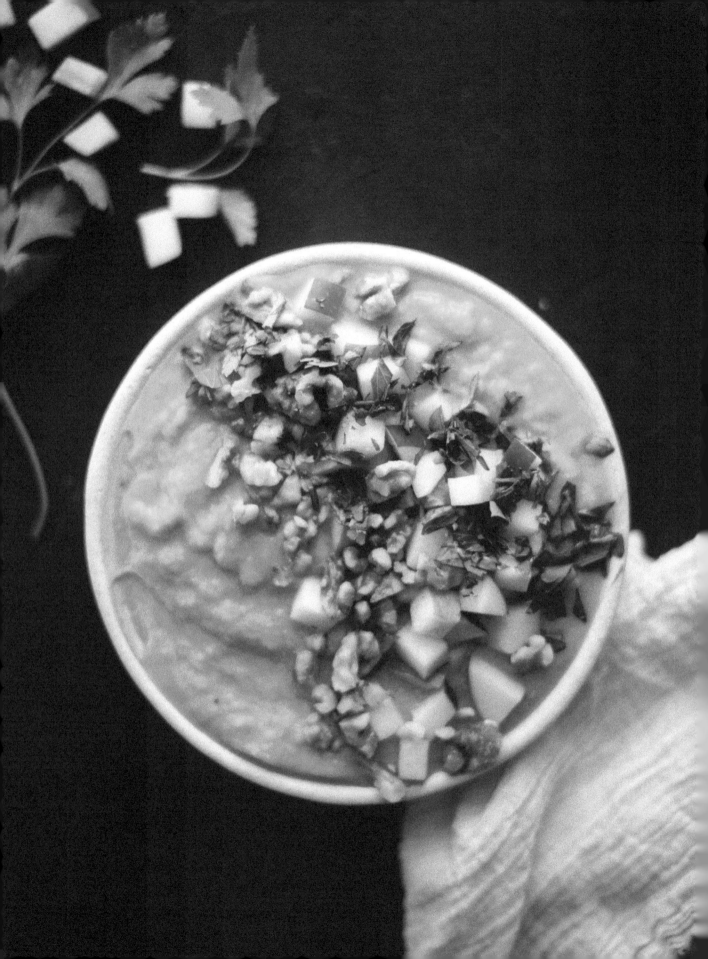

AUTUMN SOUP
with apples, walnuts and herb oil

MAKES 6 BOWLS OF SOUP
SPECIAL EQUIPMENT: HIGH-SPEED BLENDER

This soup has a tremendous depth of flavor that comes solely from browned veggies. It blows my mind how delicious this soup is, given how healthy it is, too. The infused oil and toppings take this soup to the next level. I love this soup with walnuts and apples on top, but I encourage you to experiment and find the topping you most love with this amazing beet soup.

1. Heat oil in a large sauté pan over medium-high heat until hot, then add chopped carrots, celery, yellow onion and beets to the pan and sprinkle with sea salt.

2. Cook veggies over medium-high heat, moving them around in the pan with a spatula to evenly cook and avoid burning the veggies. Continue for about 13 minutes, until soft with some browning.

3. Once the veggies are cooked, blend them in a high-speed blender in two batches, with as much of the vegetable broth as is needed to get your blender working and the soup smooth. Be careful not to fill past the hot liquid line on your blender as this could cause the top to explode off the blender.

4. Over low heat, combine all of the blended soup and any remaining broth into a large pot. Heat through, about 5 minutes, stirring occasionally and being careful to keep it from boiling.

5. While soup is heating on the stove, combine olive oil, rosemary and sea salt in a small jar with a lid and shake until well combined.

6. To serve, ladle soup into bowls and top with walnuts and apple along with a drizzle of rosemary olive oil.

Soup
4 tablespoons avocado oil (for cooking)
6 large carrots, chopped
6 stalks of celery, chopped
1 medium yellow onion, chopped
3 large golden beets, chopped
1 teaspoon sea salt
4 cups premade vegetable broth without cane sugar

Rosemary Olive Oil
½ cup olive oil
2 tablespoons fresh rosemary, minced
½ teaspoon sea salt

Garnish
¼ cup toasted walnuts, chopped (see toasting nuts and seeds, page 55)
¼ cup your favorite apple, diced

SPIRALIZED SALAD
with apple, cucumber and jicama

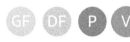

MAKES 2 QUARTS OF SALAD
SPECIAL EQUIPMENT: SPIRALIZER WITH 3-MM SPAGHETTI STYLE BLADE

When I first got my spiralizer I felt like the sky was the limit on the veggies and fruits I could turn into curl and noodle versions of themselves. But I quickly fell into a zucchini and sweet potato spiral-noodle rut and didn't think twice about it. So, many years later, it came to me as nothing less than a revelation when my sister-in-law said she was making coodles (cucumber noodles). I remembered my once strong spiral-noodle ambition and took it as a challenge to experiment. I present to you a recipe from one of my success stories. I spiralize cucumbers, apples and jicama, add a bright and zingy combination of acids and finish with sesame seeds and mint. If you're anything like my kids, you'll be craving this salad on a regular basis soon after trying it. This salad is great alone and also pairs well with lean meats like chicken and fish.

Salad

2 large honeycrisp or similar apples, spiralized

2 medium cucumbers (not too thin), spiralized

1 small jicama, spiralized (cut off skin and quarter before spiralizing)

¼ cup mint leaves, minced

Dressing

¼ cup + 2 tablespoons lemon juice

¼ cup apple cider vinegar

¼ teaspoon sea salt

¼ cup sesame seeds, toasted (see toasting nuts and seeds, page 55)

Toasted sesame seed oil, to drizzle on top

1. Combine spiralized apples, cucumbers and jicama, along with the mint into a bowl.

2. Make dressing by combining lemon juice, apple cider vinegar and sea salt into a small jar with a lid and shake until well combined. Pour prepared dressing on top of spiralized fruit and veggies and toss to coat.

3. Sprinkle toasted sesame seeds all over the top, drizzle with toasted sesame seed oil and serve.

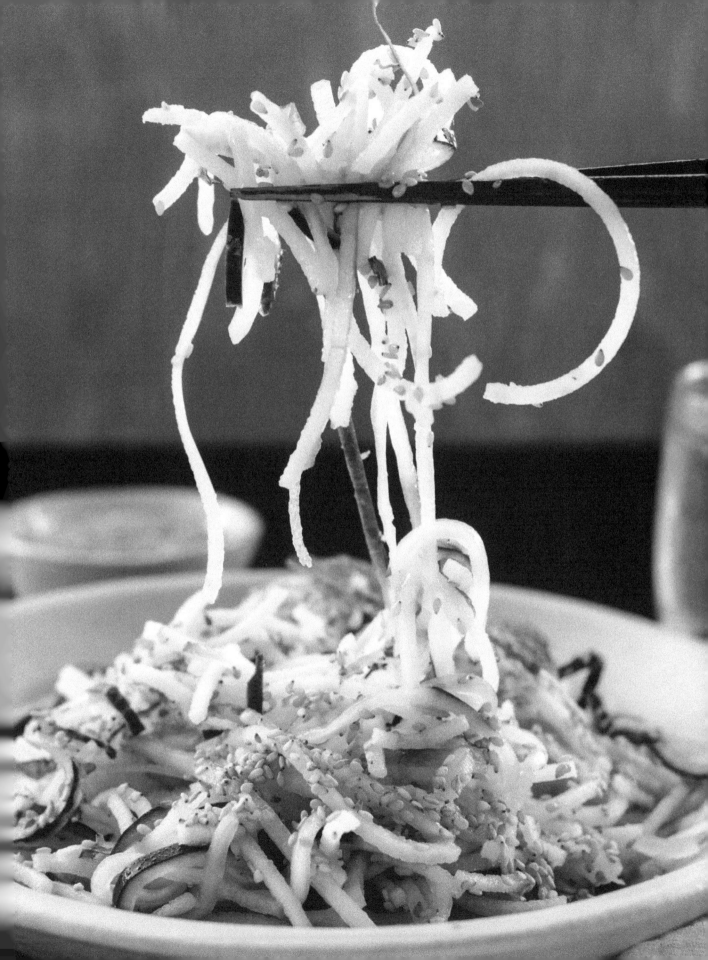

BRUSSEL SPROUT SALAD
with jicama, carrots, pine nuts and cranberries

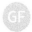

MAKES 6-8 SERVINGS
SPECIAL EQUIPMENT: FOOD PROCESSOR

This recipe is made super simple with a food processor. It is fun to process the veggies, and the small, evenly cut veggies taste so much better when you don't have to labor through the prep work by hand. Just chop, toss and enjoy. This salad is great as a Thanksgiving side, or in combination with meat or seafood for a light lunch.

1. Fit your food processor with the slicing blade, and run all the brussel sprouts through. Scrape brussel sprouts out of the food processor into the serving bowl, drizzle with olive oil and sprinkle with sea salt. Using your hands, massage sprouts with olive oil and salt until they start to break down and are more pliable.

2. Fit your food processor with the grater blade and run all of the carrots and jicama through.

3. Combine sliced and massaged brussel sprouts, grated jicama and carrots, cranberries, toasted pine nuts and lemon juice in a large bowl. Toss until well mixed before serving.

16 ounces of brussel sprouts, thick base removed if needed

4 tablespoons olive oil

½ teaspoon sea salt

4 carrots

½ medium jicama

1 cup dried cranberries sweetened with apple juice, not cane sugar

½ cup toasted pine nuts (see toasting nuts and seeds, page 55)

¼ cup lemon juice

SUMMER FRUIT SALAD
with peach, strawberry and watermelon

MAKES 6 CUPS OF FRUIT SALAD, PLUS EXTRA SYRUP
PLAN EXTRA TIME: SYRUP NEEDS 30 MINUTES TO STEEP

Once summer hits, I find these three fruits sitting together in my kitchen. It is a treat to have them there as the temperatures rise and weekend family gatherings move outside by the pool and often smell of grill smoke. This trio of fruit is the perfect bite of summer; cut small to ensure you get them all on your spoon at once. The syrup for this recipe also works well to pour over other fruit or into drinks. Double this recipe for a larger crowd, and if you happen to have any leftovers, blend them with ice and rum for a summer mojito. You'll be glad you did.

Honey mint syrup

¼ cup lemon juice

½ cup water

2 tablespoons honey (or maple syrup for vegan option)

2 stalks mint

2 (2-inch) sections of lemon or lime rind

Fruit salad

½ small watermelon, rind removed and diced small (about 4 cups)

10 large strawberries, diced small

2 medium peaches, pitted and diced small

1 tablespoon mint, minced for garnish

For the syrup:

1. Add the lemon juice, water and honey into a small saucepan and bring to a low simmer over medium heat. Once simmering, remove from heat and add the stalks of mint and lemon or lime rind to the hot liquid and allow to steep for at least 30 minutes, but no more than an hour. Strain the mint and rinds from the liquid and reserve the syrup. Set syrup aside to cool for 10 minutes or until cool to the touch (you don't want hot syrup cooking the fruit). Keep any extra syrup in an airtight container and store in the fridge.

For the fruit salad:

1. Combine diced watermelon, strawberries and peaches to a large bowl and lightly toss.

2. Pour half of the syrup (a scant ½ cup) over the fruit. Lightly toss fruit until it is coated with syrup, being mindful to not squash the peaches and strawberries as you toss. Taste and add more syrup if desired.

3. Sprinkle minced mint garnish on top.

4. Serve immediately, or store in the fridge for up to a day.

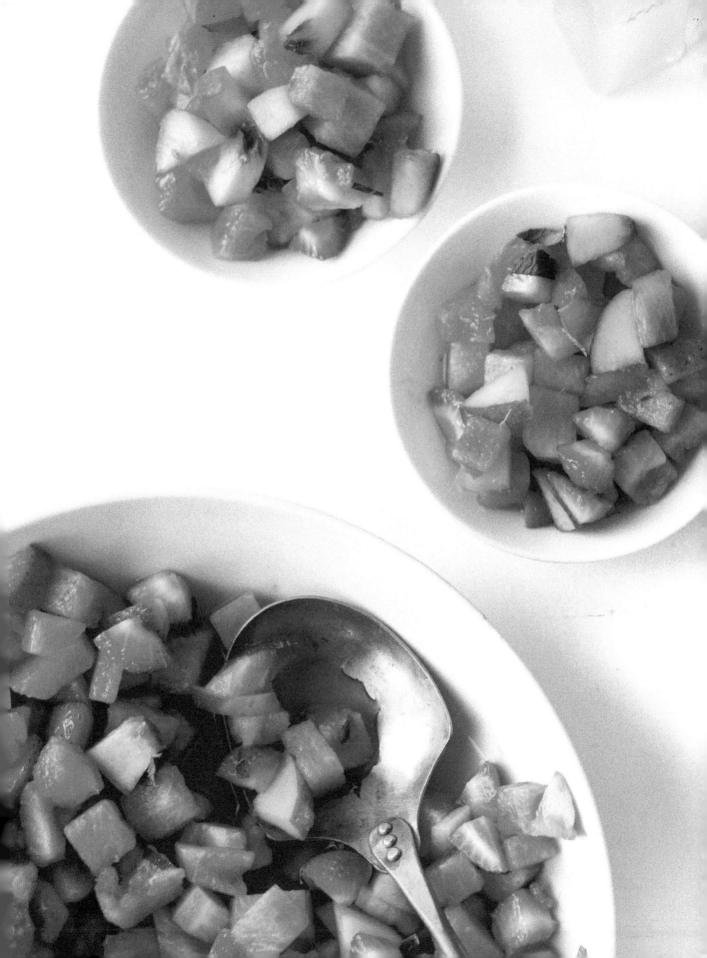

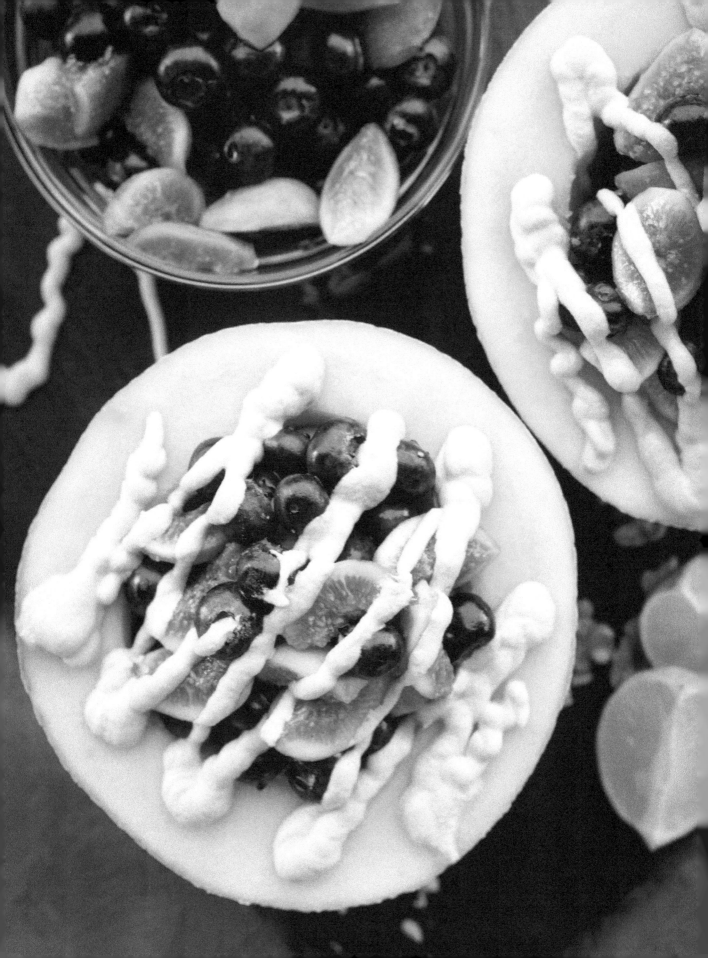

CANTALOUPE FRUIT BOWL

MAKES 4 SERVINGS (4 HALF CANTALOUPE BOWLS) PLUS EXTRA WALNUT CREAM
SPECIAL EQUIPMENT: HIGH-SPEED BLENDER AND OPTIONAL SQUEEZE BOTTLE
PLAN EXTRA TIME: WALNUTS NEED TO SOAK FOR AT LEAST 6 HOURS

Figs are one of those tender, elusive fruits you find fresh typically only once a year (more if you're lucky!). A gorgeous fig tree is deeply rooted in the backyard of the home where I live so the end of July has become a mad scramble to find recipes honoring this delight, which lasts a few days once relieved from fruit-heavy branches. Here, I've married figs with blueberries, melon and walnut cream in a dessert so good you'll want to (and should!) eat the bowl.

1. For the syrup, combine all ingredients for the syrup in a small saucepan and bring to a simmer over medium heat. Once the liquid is simmering, remove from heat and stir to make sure the honey is dissolved.

2. Allow the syrup to cool for at least 10 minutes or until cool to the touch.

3. For the walnut cream, combine all ingredients for the walnut cream into a high-speed blender and blend on high until very smooth, about 30 seconds. Transfer cream into a squeeze bottle or bowl so it is ready to put on top.

4. Prepare cantaloupe bowls by cutting each in half along the equator and scraping out seeds from the center of the cantaloupe. To create a flat surface for the cantaloupe to sit on, you can slice off the rounded bottom of the half-melon, being careful not to remove too much of the fruit.

5. Mix blueberries and figs together in a medium bowl.

6. Pour cooled syrup over the blueberries and figs and then toss gently to coat the fruit.

7. To serve, spoon the blueberry and fig mixture into the center of each cantaloupe and top generously with walnut cream (a few tablespoons to a ¼ cup, depending on taste). Serve immediately.

Syrup
2 tablespoons lemon or lime juice
¼ cup water
2 tablespoons honey (or maple syrup for vegan option)

Walnut cream
1 cup raw walnuts, soaked then drained (see note)
½ cup water
2½ teaspoons date syrup
1 teaspoon vanilla
¼ teaspoon sea salt

For the bowl
2 small cantaloupe
1 pint fresh blueberries
15 small fresh figs, stems removed and cut in half

TO SOAK WALNUTS Cover raw walnuts in water and place in the fridge for 6-12 hours. When ready to use, strain off water before putting walnuts into the blender. Soaked nuts yield a cream instead of nut butter when blended.

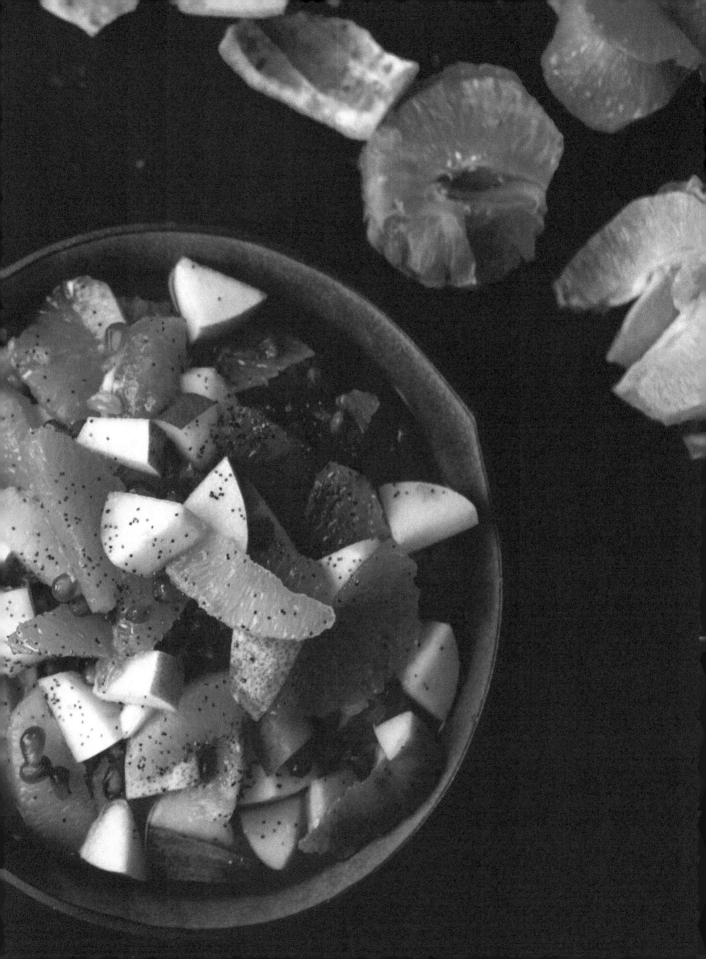

WINTER FRUIT SALAD
with warming turmeric dressing

MAKES ABOUT 3 QUARTS

Winter is not my favorite season. Short days, dark afternoons… it gets a little drab. I think it is nothing short of a miracle that we have some of the best fruit in the world come into season during the months we wish everyone would just leave us alone to sit in the dark and dream of spring. Pears, citrus and pomegranates to the rescue! They make even the darkest days a little brighter. I pair them here with a cold-fighting turmeric dressing to warm and brighten a winter day or your holiday table.

1. Combine all prepared fruit in a large bowl.

2. To make dressing, heat lime juice, water, fresh turmeric, honey and sea salt in a small saucepan over medium-low heat until liquid begins to simmer, then turn to low for 7-8 minutes, stirring occasionally to make sure the honey dissolves. Remove from heat and strain (to remove bits of grated turmeric) into a heat safe container. Add poppy seeds and black pepper. Stir dressing together until well mixed, allow dressing to cool for 5-10 minutes, then pour over fruit.

3. Gently toss the fruit salad to coat with dressing, and serve or cover to store in the fridge to eat the next day.

SUPREME To supreme, cut away the outer rind and all of the white pith, then cut the citrus wedges from the membrane which will leave you just juicy fruit for your dish.

Fruit Salad

2 navel or other oranges, supremed (see note)

1 blood orange, supremed

2 grapefruit, supremed

1 cup pomegranate seeds

2 pears, diced

Dressing

2 tablespoons lime juice

½ cup water

2 teaspoons fresh turmeric, grated

2 tablespoons honey or maple syrup for vegan

¼ teaspoon sea salt

1 teaspoon poppy seeds

Fresh ground pepper to taste

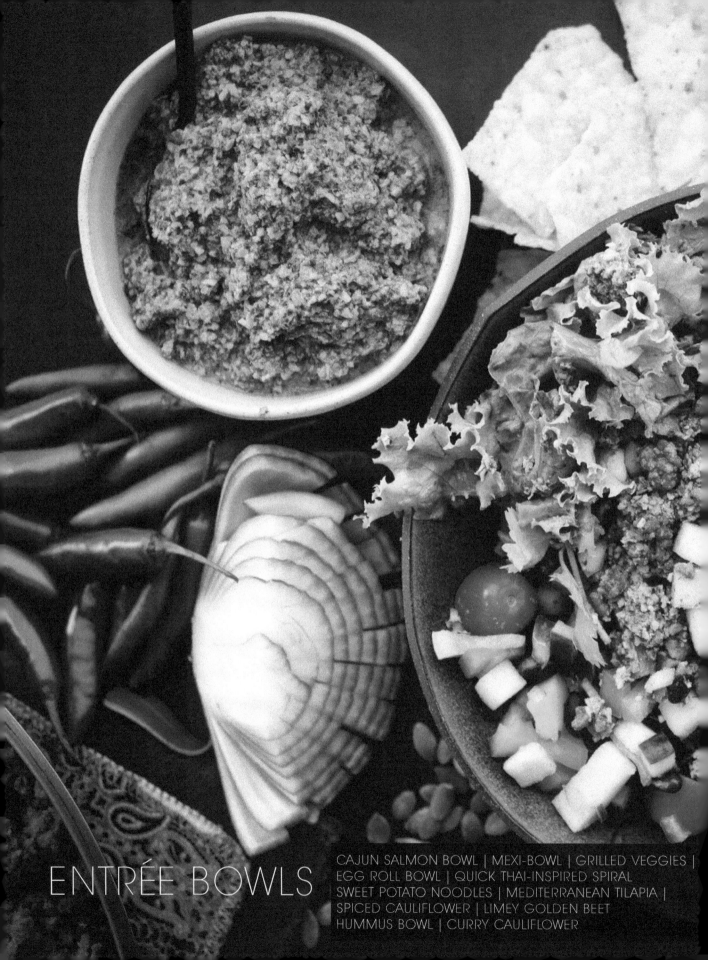

ENTRÉE BOWLS

CAJUN SALMON BOWL | MEXI-BOWL | GRILLED VEGGIES |
EGG ROLL BOWL | QUICK THAI-INSPIRED SPIRAL
SWEET POTATO NOODLES | MEDITERRANEAN TILAPIA |
SPICED CAULIFLOWER | LIMEY GOLDEN BEET
HUMMUS BOWL | CURRY CAULIFLOWER

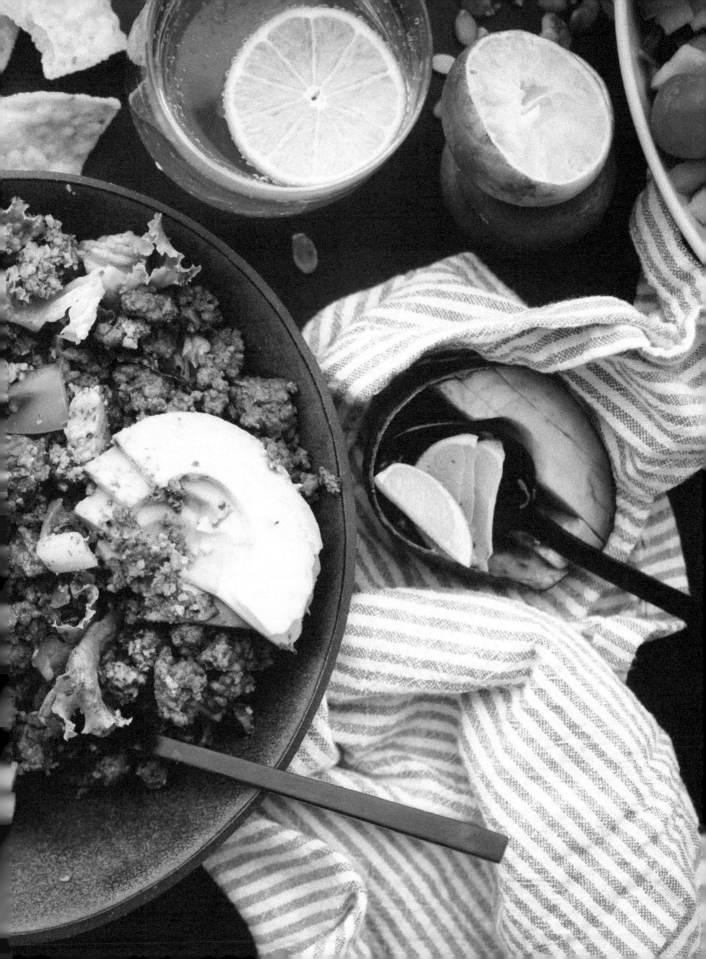

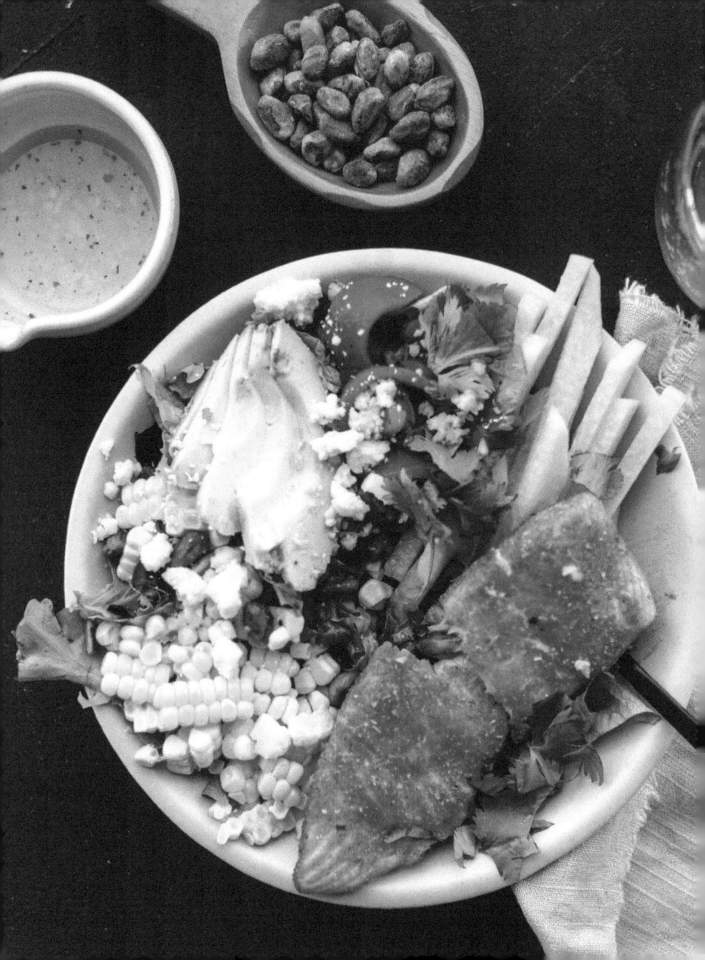

CAJUN SALMON BOWL

MAKES 2 DINNER SALADS

This delightful salad marries classically Mexican veggies with Cajun-spiced salmon. Get excited to try the pistachios paired with salmon; it's one of my favorite combinations! You are going to love cooking salmon this way, on a slightly lower temperature and coated with spices. The salmon consistently turns out moist and full of flavor with very little active time. If you've got a toaster oven at home, use it to cook the salmon! Several reasons why I love using my toaster oven for more than just toast: No need to heat the whole oven, the temperature is more likely to be on point, the wait time for preheating is way shorter than a full-sized oven and the small pan will be the perfect size for a few pieces of salmon. (I like to line mine with aluminum foil to make cleanup a cinch!) Once you try this you'll have a new favorite technique to get a delicious dinner on the table quickly.

1. Preheat oven or toaster oven to 325°F and lightly grease (or line with aluminum foil) a small baking pan.

2. In a small bowl mix together all ingredients to season the salmon (cumin, garlic, paprika, oregano and sea salt). Pour spice mix out onto a plate at least as large as your portions of salmon.

3. Pat salmon dry with paper towels, and then lay each side down into the spice mixture until salmon is entirely coated. Place onto the prepared baking pan, then into the oven and bake for 17 minutes until salmon light pink and flaky.

4. While salmon is baking, prepare the dressing by putting all ingredients into a small glass jar with a lid and shaking until well mixed.

5. Once salmon is ready, put everything together into two bowls. Start with the lettuce, and then add in red pepper, corn, jicama, avocado and salmon. Top with crumbled cotija cheese (if using), pistachios and dressing. Enjoy!

Salmon

¼ teaspoon ground cumin

¼ teaspoon ground garlic

¼ teaspoon smoked paprika

¼ teaspoon oregano

¼ teaspoon sea salt

2 (6-ounce) portions of salmon

Salad

5 ounces romaine or similar lettuce, washed and chopped

¼ cup roasted red pepper from a jar, sliced into thin strips

2 ears of raw corn, kernels cut from the cob

¼-½ small jicama, cut into ½-inch spears

1 avocado, diced or sliced

¼-½ cup cotija cheese, crumbed (optional, omit for dairy free)

½ cup pistachios, shelled

Dressing

Juice from ½ a lemon or 1 lime

2 tablespoons olive oil

1 clove of garlic, minced

1 teaspoon sea salt

¼ teaspoon cracked black pepper

MEXI-BOWL
with herby pepita dressing

MAKES 4 DINNER BOWLS, PLUS EXTRA DRESSING

Taco salads found their way into meal rotation early in the healthy eating escapade that now constitutes my diet. The reason for this is simple: They are delicious, versatile, quick and easy. Dinner is on the table promptly and made from a fresh combination of whatever veggies you have on hand, chips and ground meat that requires little attention. This recipe is a nod to those delicious meals of my humble cooking beginnings, adds a special dressing and comes with an easy way to cook taco meat that you will be able to recreate weekly forevermore.

Bean and corn relish

1 (15-ounce) can of black beans, drained
 and rinsed

2 ears of fresh corn, kernels cut from the cob

1 bell pepper, diced small

1 small zucchini, diced small

½ medium red onion, diced small

The juice from 2 limes

1 teaspoon ground cumin

1 teaspoon sea salt

Ground beef

2 pounds 85%- or 90%-lean ground beef

1½ cups vegetable broth

1 tablespoon chili powder

2 teaspoons ground cumin

½ teaspoon granulated garlic

1 teaspoon dried oregano

1 teaspoon sea salt

2 tablespoons tomato paste

For the bowl

5 ounces romaine or other crunchy lettuce,
 chopped for serving

1 avocado, sliced for serving

Corn tortilla or cassava chips (optional),
 for serving

½ jicama, outer skin removed and cut into
 spears for serving

Recipe for Herby pepita dressing
 (page 44 and page 102)

1. Combine all ingredients for the bean and corn relish into a large bowl and toss to evenly coat veggies with lime juice, cumin and sea salt.

2. Heat a large skillet on medium-high heat and add the ground beef. Break the ground beef into small bits with a spatula, and cover the bottom of the skillet with the meat. Leave meat alone to cook and brown on one side for 6-8 minutes, watching for burning or scorching. Then turn over any uncooked parts of the meat onto the hot pan surface until cooked through.

3. Combine broth with the next six ingredients in a pourable container and stir until well combined. Pour spiced broth into the pan with the beef and scrape any browned bits off the bottom of the skillet. Make sure the broth is evenly through the meat and bring to a simmer over medium-high heat. Reduce heat to medium-low and simmer until slightly reduced and thickened, about 5 minutes.

4. To serve, arrange lettuce, meat, bean and corn relish, herby pepita dressing, avocado, chips (if using) and jicama to a bowl and serve.

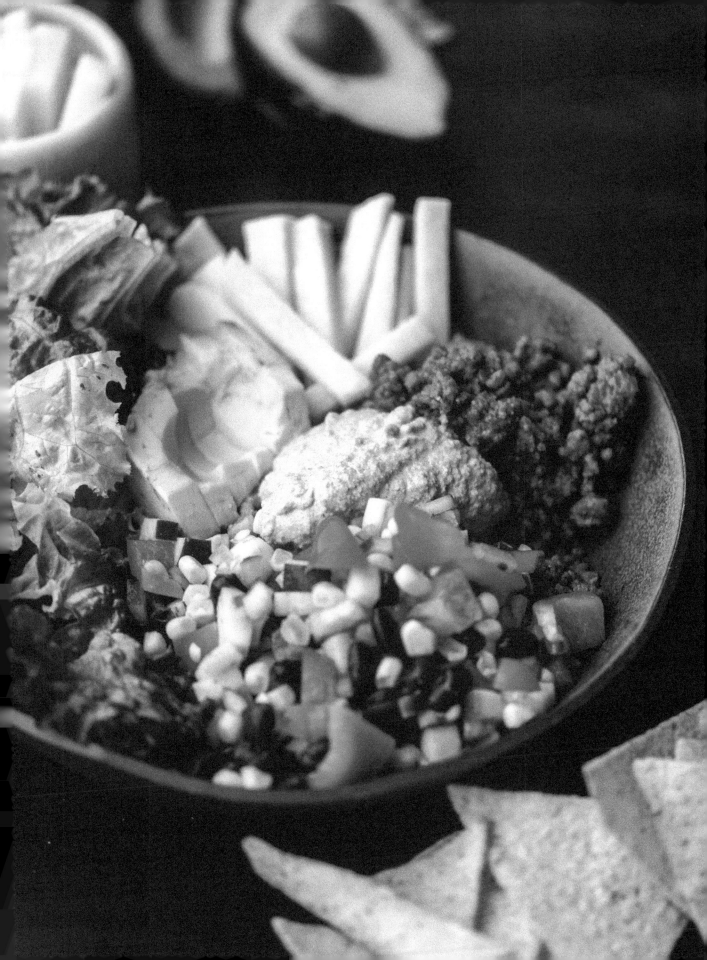

GRILLED VEGGIES
with mung beans and sunflower tahini alfredo

MAKES 4 BOWLS
PLAN EXTRA TIME: BEANS COOK FOR 45 MINUTES; GRILLED SALAD PREP TIME IS ABOUT 45 MINUTES

Mung beans are certainly not the sexiest bean in the market, but I love them for their easy cooking (no soaking and a short cook time!), their nutrient density, and vegan protein. For an added nutrient boost, I cook the beans with dulse seaweed. Dulse changes the flavor very little, it will mostly read as salt when you eat the beans. I pair the mung beans with something you should know about if you don't already: the grilled salad. Did you know you could grill veggies and *then* cut and combine them for a salad? I didn't until a friend showed me the light, and it's been one of my favorite summer indulgences ever since. And lastly, who in the vegan/allergen-free world doesn't miss Alfredo sauce? The sauce on this recipe is very similar to Alfredo and completely vegan.

Mung Beans

2 cups mung beans, uncooked but rinsed thoroughly

¼ cup dulse (or sub ½ teaspoon sea salt)

1 tablespoon fennel seeds

1 teaspoon ground ginger

1 teaspoon ground cumin

1 teaspoon dried oregano

Grilled veggies

3 portabella mushrooms, thick stems removed

1 small head of green cabbage, cut into 8 wedges

2 red peppers, seeds removed and sliced into large chunks

2 medium zucchini, cut into 4 spears each

2 medium yellow summer squash, cut into 4 spears each

4 ears of corn

¼ cup olive oil

½ teaspoon sea salt

Recipe for Sunflower tahini alfredo (next page and page 108)

1. Place all ingredients for the mung beans into a medium saucepan and heat over medium-high heat until boiling. Then, turn down to a simmer, cover and cook beans for 45 minutes. While the beans are cooking, grill the veggies for the grilled veggie salad.

2. On a hot preheated grill, start grilling your veggies. Lay veggies directly on grill grate in a single layer. Grill hotness can vary so times below are estimated, but cook until desired texture is achieved:

 - **Mushrooms**: 8-9 minutes a side, looking for soft and slightly watery, no longer spongy
 - **Cabbage**: 7-8 minutes a side, looking for browning and grill marks on each side and wilty with a slight sweat.
 - **Red peppers**: 7-8 minutes a side, looking for some blackening on the skin and a soft inner flesh
 - **Zucchini and yellow squash**: 5-6 minutes a side, looking for grill marks and softer flesh
 - **Corn**: 4-5 minutes a side, turning 4 times to get some grill marks and heat all the way around.

3. Once veggies are cool, peel as much of the skin off of the red peppers as you are able, and then chop the mushrooms, cabbage, red peppers, zucchini and yellow squash into bite-size pieces and place together in a large bowl. Cut the corn from the cob and add it to the bowl. Then add the olive oil and sea salt and toss to coat and evenly distribute veggies through the salad.

4. After the beans have cooked for 45 minutes, remove lid and make sure beans are soft, then stir and let rest until you are ready to serve.

5. To serve, scoop mung beans and grilled salad next to each other in a bowl, then top with sunflower tahini alfredo.

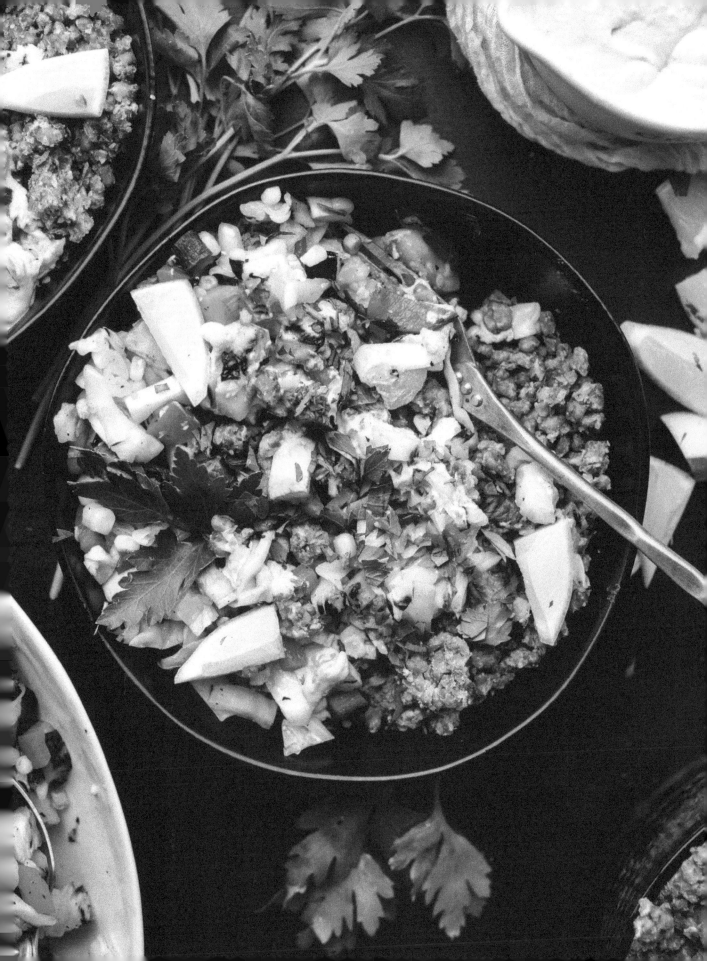

SUNFLOWER TAHINI ALFREDO

MAKES 2 CUPS
SPECIAL EQUIPMENT: HIGH-SPEED BLENDER
PLAN EXTRA TIME: SEEDS NEED TO SOAK FOR 6 HOURS

2 cups raw sunflower kernels, soaked and husks removed

¼ cup tahini

2 garlic cloves

¼ cup lemon juice

2 tablespoons coconut aminos

½ cup water

½ cup olive oil

1. Add sunflower kernels to a bowl and cover with water. Place bowl in the fridge, covered, for at least 6 hours.

2. Remove the husks from the hulled sunflower kernels by rubbing the sunflower kernels vigorously between your hands before tipping the bowl slightly over a sink and running water over the seeds, allowing the water to overflow and take the floating husks with it.

3. To make the sunflower tahini alfredo, add the soaked sunflower kernels with husks removed and all other ingredients to a high-speed blender and blend until very smooth, about 30 seconds. Transfer sauce to a serving bowl and serve immediately, or cover and store in the fridge for up to a week.

EGG ROLL BOWL
with chili garlic oil

MAKES 4 LARGE DINNER BOWLS
PLAN AHEAD: VEGGIES CAN BE PREPPED AHEAD OF TIME AND STORED IN THE FRIDGE FOR UP TO TWO DAYS.

Ah, the egg roll bowl. This recipe is something I happily make once a week. It checks so many boxes: Healthy! Grain-free! One pan! Quick! Kids love it! I am so happy to have this crowd pleaser in my back pocket when I am feeding people with dietary restrictions. I've yet to meet a crowd I couldn't please with this one. This is one of my daughter's favorite meals, but her recommendation is to swap the chili garlic sauce for Dijon mustard!

2 pounds ground pork

2 medium carrots, grated

1 small head of cabbage (about 6 cups), sliced into thin strips

8 ounces fresh baby bella or similar mushrooms, sliced

8 green onions, green parts sliced into rounds (save the white parts for the chili oil)

½ cup coconut aminos

1 teaspoon ground ginger

1 teaspoon ground garlic

¼ cup lime juice

1 large handful of basil leaves (about ½ cup packed), roughly chopped (divide and reserve 2 tablespoons for garnish, if desired)

Chopped peanuts (optional, for garnish)

Recipe for Chili garlic oil (next page and page 112)

1. Heat an extra-large, heavy-bottomed sauté pan (I use a 16" sauté pan) over medium-high heat. Once hot, add the ground pork and break up into small pieces in the pan, stirring until brown and fully cooked.

2. Add prepped carrots, cabbage, mushrooms and green onions to the pan. sauté and cook until veggies are soft, 9-12 minutes (cooking longer will yield less crunch from the cabbage, you can go longer or shorter depending on your preference).

3. Add coconut aminos, ginger, garlic, lime juice and basil leaves to the pan and turn over veggies and meat until your additions are incorporated uniformly.

4. Serve cabbage and pork mixture in a bowl with 4-6 tablespoons of chili garlic oil on top and garnish with chopped basil and peanuts (if desired).

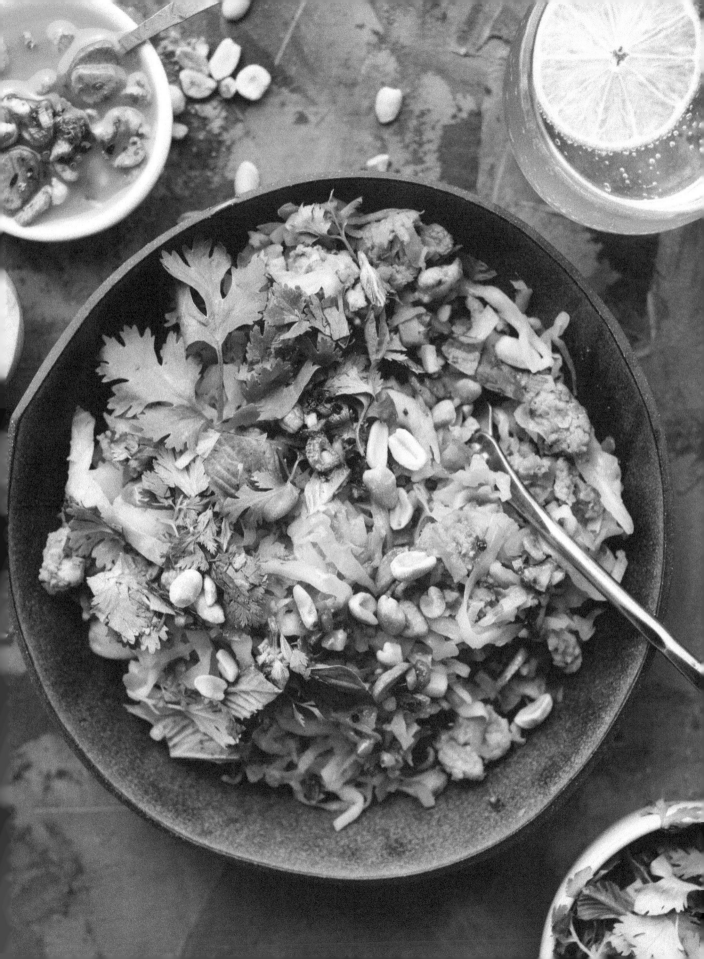

CHILI GARLIC OIL

PLAN AHEAD: SAUCE CAN BE MADE AHEAD OF TIME AND STORED IN THE FRIDGE FOR UP TO TWO WEEKS, JUST STIR OR SHAKE BEFORE USING.

1. Heat oil in a small saucepan over medium-low heat. Add sliced garlic, green onion, cinnamon sticks and star anise pods and cook them slowly in the oil until garlic and onion are golden, about 20 minutes. Go slowly with the browning and watch carefully towards the end. Garlic and onions will go from browned to burnt quickly!

2. Combine chili flakes, peanut butter, coconut sugar and coconut aminos in a glass or heat-safe bowl and stir until well combined.

3. Prepare a plate with paper towels layered on top.

4. Once garlic and onions are browned, strain the oil through a fine mesh sieve into the glass bowl with the chili flake mixture and dump the fried garlic and onions onto the plate with the paper towels. Allow the garlic and onions to dry and cool, and discard the cinnamon sticks and anise pods.

5. Once fried garlic and onions have cooled, add them to the glass bowl with the oil and other ingredients and stir until everything is well incorporated.

6. Cover and store in the fridge for up to 2 weeks. Shake or stir well before serving as chili flakes will sink to the bottom.

1½ cups avocado oil

2 heads of garlic, cloves removed from paper skin and sliced thin

8 green onions, white parts only and cut into rounds

1 cinnamon stick

3 star anise pods

1 tablespoon aleppo (or similar) chili flakes

3 tablespoons chunky natural peanut butter (only peanuts in ingredient list)

1 teaspoon coconut sugar

2 tablespoons coconut aminos

QUICK THAI-INSPIRED
spiral sweet potato noodles

MAKES: 2 BOWLS
SPECIAL EQUIPMENT: SPIRALIZER WITH 3MM SPAGHETTI STYLE BLADE

Spiralized sweet potatoes are an endlessly satisfying treat. They are delicious pan-fried in butter or oil and they cook up quickly. I eat them with everything from beans to fruit, but here I'm inspired by Thai flavors. I add green onions and mushrooms while the sweet potatoes are cooking and top with basil, lime and coconut aminos for a quick and delicious meal. I love pairing avocado with sweet potatoes and I add them here for heft, but leave that addition optional. Try this one with the chili garlic oil on the previous page!

4-6 tablespoons butter or cooking oil (use cooking oil for vegan)

2 medium sweet potatoes, spiralized (about 4 cups); I use a 3mm spaghetti style blade

6-8 green onions, white and green parts cut into rounds

8 ounces fresh baby bella or similar mushrooms, sliced

1 lime, cut into wedges for serving

2 tablespoons fresh basil or thai basil leaves, minced for garnish

1 avocado, sliced in strips for serving (optional)

1 tablespoon coconut aminos, for drizzling

1. Heat 2 tablespoons of the butter or cooking oil in a large sauté pan over medium-high heat and then add the spiralized sweet potatoes.

2. Cook the sweet potatoes in the pan, turning often with a spatula. Whenever the potatoes start looking dry, add a tablespoon of butter or cooking oil to the pan. Once the sweet potatoes are soft, 4-5 minutes, add the green onions and mushrooms to the pan.

3. Cook the sweet potatoes, mushrooms and green onions together in the pan, turning over constantly, until mushrooms and green onions are tender, 3-4 minutes.

4. To serve, put sweet potatoes, mushrooms and green onions into bowls and squeeze a wedge of lime over top. Add minced basil and avocado (if using) and drizzle with coconut aminos.

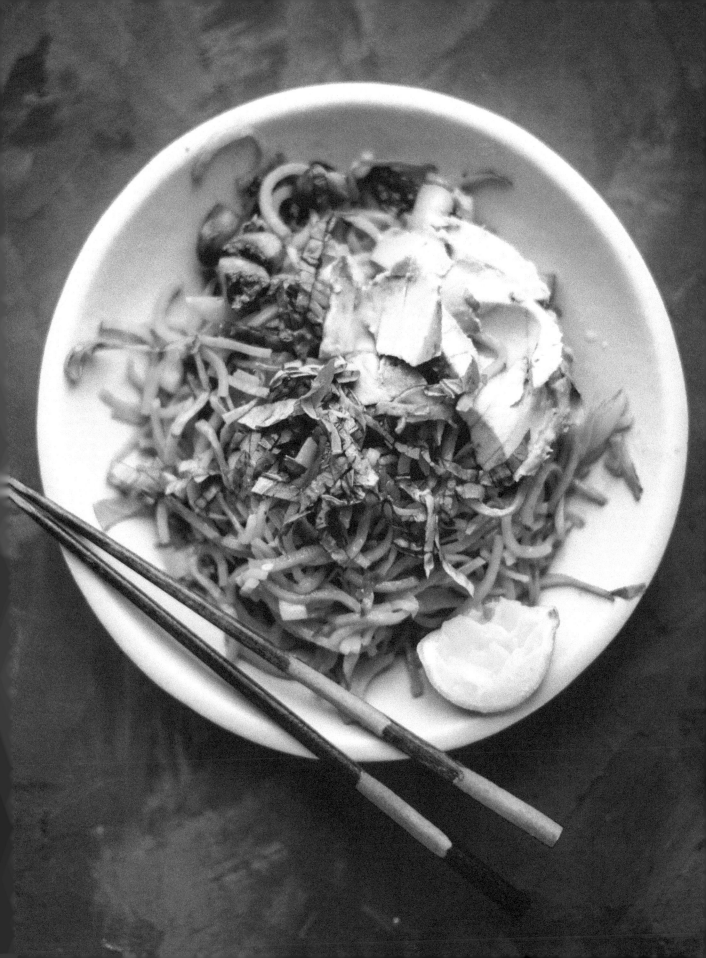

MEDITERRANEAN TILAPIA

MAKES 2 LARGE DINNER BOWLS

This combination of Mediterranean flavors is a welcome change to the flavor profile on my typical dinner menu. I turn to this recipe when I want to pull myself out of an eating-the-same-thing-for-dinner rut. Nothing is too complicated here, but you will have several different components to think about, so plan your time accordingly.

Cherry tomatoes

1 pint cherry tomatoes

3 ounces fresh basil, stems removed and leaves chopped

3 tablespoons olive oil

½ teaspoon of sea salt

Spiced ghee

½ cup ghee

2 tablespoons coriander seeds

1 teaspoon whole cloves

Cauliflower and lentils

2 tablespoons butter, ghee or cooking oil

12 ounces riced cauliflower (frozen or not)

1 (15-16 ounce) can of lentils, strained and rinsed

¼ teaspoon sea salt

Tilapia

2 tilapia filets, fresh or thawed

¼ teaspoon sea salt

¼ teaspoon dried dill

2 tablespoons, butter, ghee or cooking oil

Recipe for Olive tapenade (next page and page 110)

1. Preheat oven to 350°F. Toss tomatoes and basil with salt and oil in a bowl and then spread out on a sheet pan. Sprinkle with sea salt and place in oven for 15-20 minutes until tomatoes are starting to blister. Remove from oven and reserve for serving.

2. While tomatoes are roasting, combine ghee, coriander seeds and cloves in a small saucepan over medium-low heat, and simmer for about 20 minutes, being careful to not let the melted ghee get too hot and burn the seeds. Strain ghee through a fine mesh sieve into a glass bowl. Discard coriander and cloves. Reserve spiced ghee for serving.

3. Heat butter or cooking oil for cauliflower in a medium sauté pan over medium-high heat. Once hot, add the riced cauliflower and if frozen, break apart. Spread out riced cauliflower evenly across the bottom of the pan. Cook the cauliflower on one side for 5-7 minutes, which will allow the cauliflower to start to brown. With a wide spatula, turn over cauliflower rice and cook for another 4-5 minutes on the other side.

4. Once the cauliflower is soft and has some browning, add the lentils and sea salt to the cauliflower and stir with a spatula or spoon until well mixed and lentils are heated through. Remove from heat and reserve for serving.

5. Last component! Prepare tilapia filets by drying them with paper towels and sprinkling them with sea salt and dried dill. Heat the olive oil in a medium sauté pan over medium-high heat and once hot, add tilapia filets. Cook tilapia about 3 minutes on each side, until white and flaky all the way through.

6. Put it all together! In your carefully selected bowl, layer cauliflower and lentils, fish and tomatoes and basil (in that order). Top with a generous amount of olive tapenade and drizzle the whole thing with the spiced ghee. Enjoy!

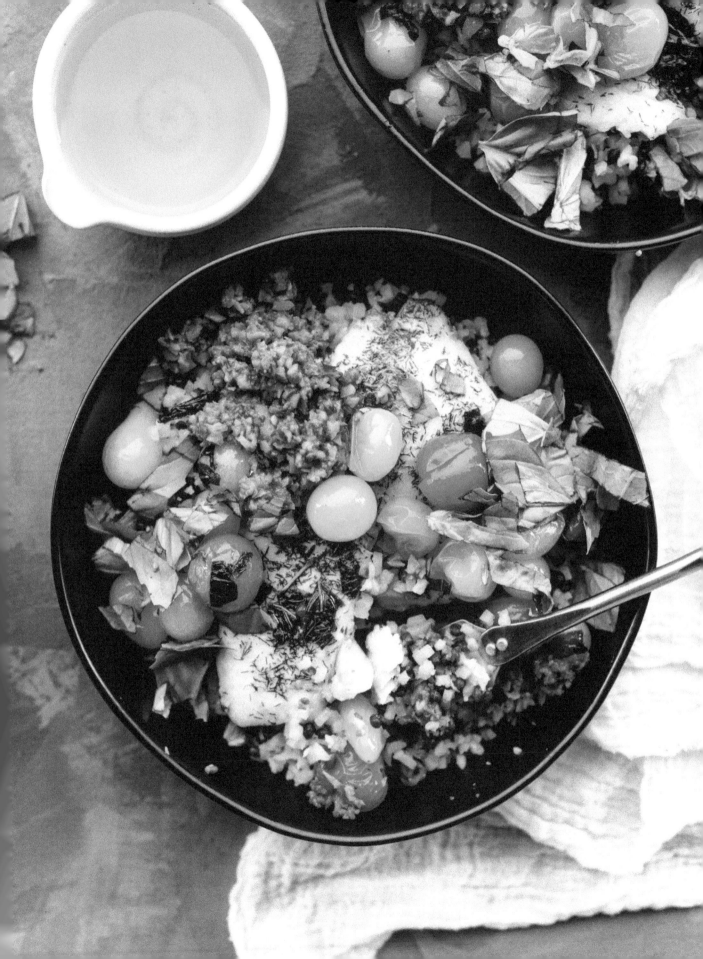

OLIVE TAPENADE

SPECIAL EQUIPMENT: FOOD PROCESSOR
PLAN AHEAD: TAPENADE CAN BE MADE AHEAD AND STORED IN THE FRIDGE

1 pint pitted olives
 (kalamata, green or a
 mix of both)

2 garlic cloves

6 sundried tomatoes, dried
 or packed in oil

2 tablespoons olive oil

3 tablespoons lemon juice

1. Put all ingredients into a food processor and pulse until ingredients are all roughly the same size and evenly distributed.

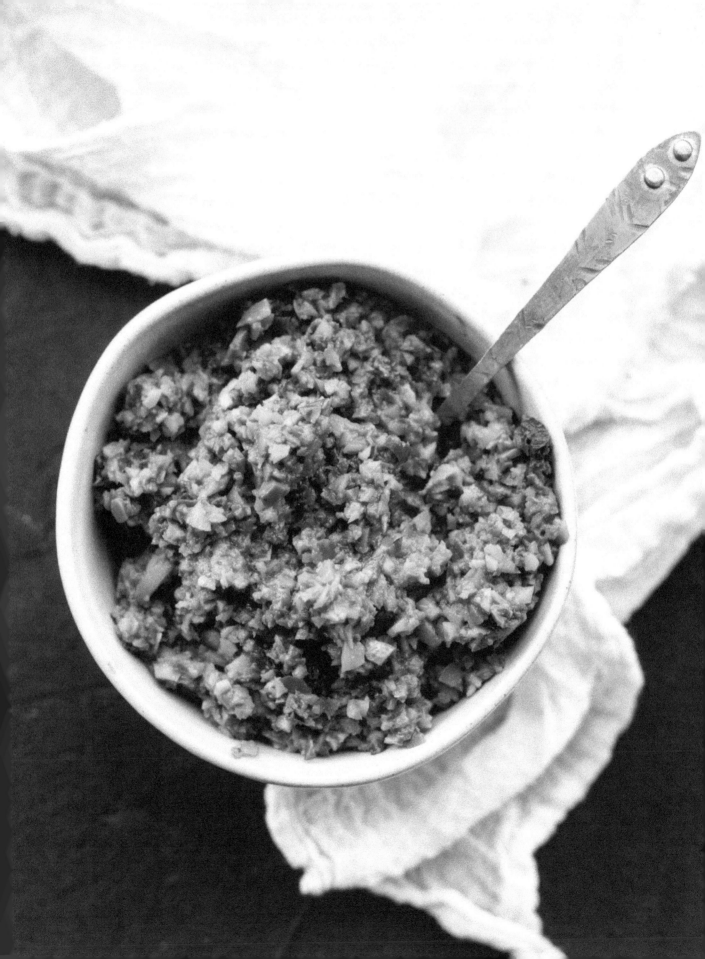

SPICED CAULIFLOWER
with beans, slaw and vegan ranch

MAKES 4 DINNER BOWLS

Vegan, grain-free comfort food isn't easy to come by, but I love this recipe because it is just that. The silky beans and corn are a compliment to the crunchy coleslaw and spiced, baked cauliflower. It all gets pulled together with a garlicky vegan ranch dressing. Here's some comfort food you can count on to keep you feeling good long after you eat it.

Spiced cauliflower

2 tablespoons avocado oil

¼ teaspoon onion powder

¼ teaspoon granulated garlic

½ teaspoon chili powder

½ teaspoon mustard powder

1 teaspoon sea salt

1 large head cauliflower, cut into 1-inch florets and pieces

Slaw

¾ small head of napa cabbage, sliced thin from leafy end

1 medium fennel bulb, green tops removed and sliced thin

4 stalks of celery, sliced thin perpendicularly

2 teaspoons sea salt

3 tablespoons lemon juice

Corn and beans

3 tablespoons cooking oil of choice

1 ear of raw corn, cut from the cob

1 (15-16 ounce) can of white beans, drained and rinsed

Recipe for Vegan ranch (next page and 104)

1. Preheat oven to 375°F.

2. In a bowl large enough to hold all of the cauliflower, mix together the avocado oil and the next five ingredients though the salt. Add the cauliflower to the bowl and toss in the spiced oil with your hands or a spoon until the cauliflower is evenly coated in the spiced oil.

3. Turn the cauliflower out onto a baking sheet and spread the cauliflower evenly over the pan in a single layer. Once the oven is preheated, bake cauliflower until lightly browned and tender, about 40-45 minutes, turning over the cauliflower halfway through.

4. For the slaw, combine the cabbage, fennel, celery, sea salt and lemon juice in a bowl and toss.

5. Heat oil over medium-high heat until melted or hot. Add corn and cook for 2-3 minutes on one side, then add beans to the pan and sauté until heated through, about 2 minutes, stirring occasionally.

6. To serve, put baked cauliflower, slaw, beans and corn side by side in a bowl, and top with dressing.

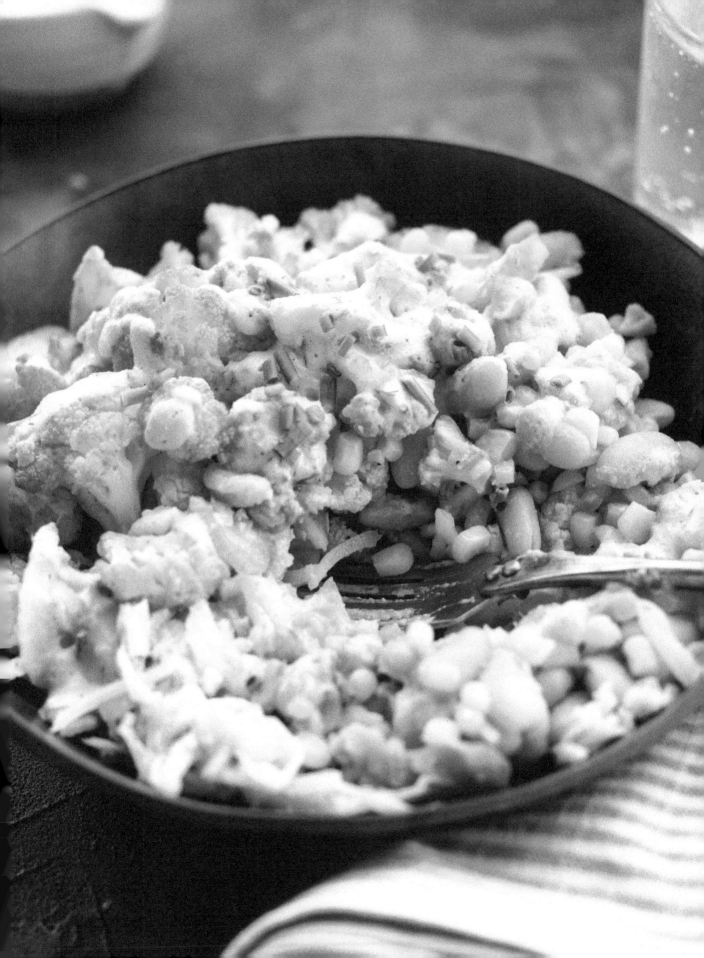

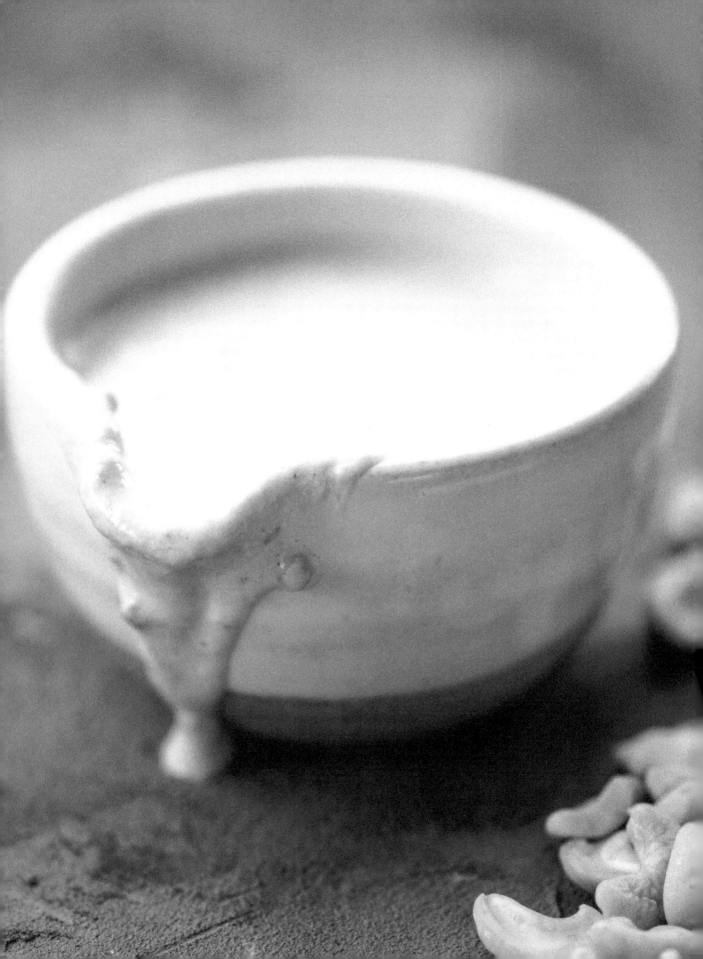

VEGAN RANCH

SPECIAL EQUIPMENT: HIGH-SPEED BLENDER
PLAN AHEAD: DRESSING CAN BE MADE AHEAD OF TIME AND STORED IN THE FRIDGE

1. For the sauce, combine cashews, garlic, water and sea salt in a high speed blender and blend on high until creamy and uniform, about 30-45 seconds. Remove dressing from the blender and then stir in the dill and chives.

1 cup raw cashews (no need to soak)

1 clove of garlic

1 cup water

1 teaspoon sea salt

1 teaspoon fresh dill, minced

1 tablespoon fresh chives, sliced thin

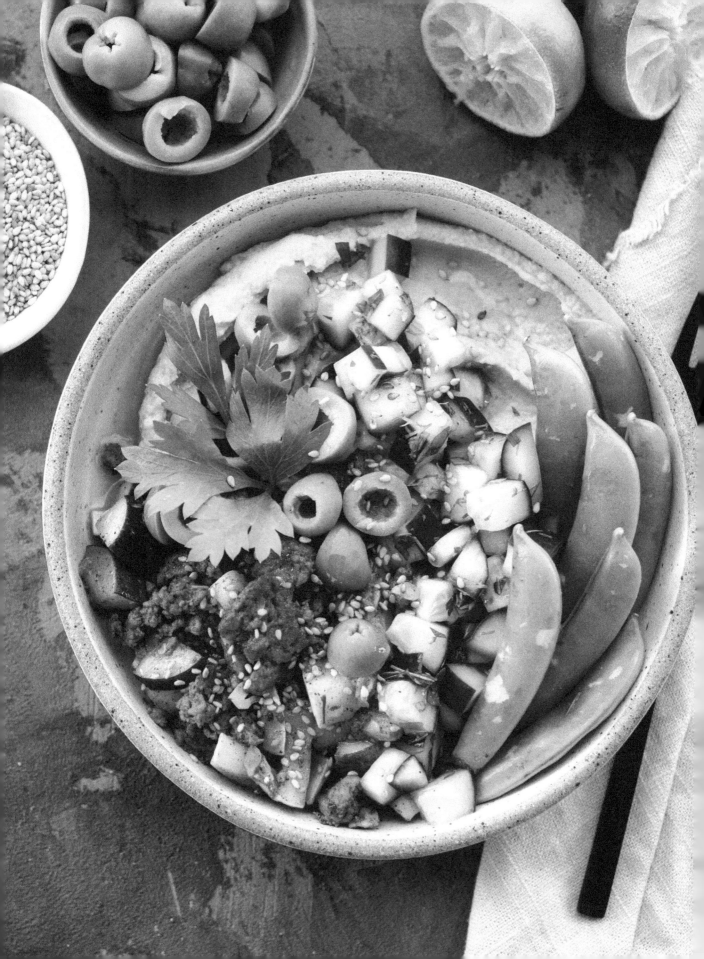

LIMEY GOLDEN BEET HUMMUS BOWL
with ras el hanout lamb and zucchini

MAKES 4 DINNER BOWLS, PLUS EXTRA HUMMUS
SPECIAL EQUIPMENT: HIGH-SPEED BLENDER
PLAN AHEAD: HUMMUS CAN BE MADE IN ADVANCE AND STORED IN THE FRIDGE

Hummus bowls give us a reason to eat snacks for dinner. And not just a little snack; this is the full-blown sitting-down-and-eating-the-entire-tub-of-hummus snacking. But it's dinner, and it is awesome. Not only because you get to eat snacks for dinner, but because it has meat and a homemade hummus that you would never spend that much time making if it were actually just a snack! So here it is: elevated and glorious snack food. For dinner.

1. Preheat oven to 375°F. Scatter beets over a sheet pan and bake, turning once, until tender, about 35 minutes.

2. Combine baked beets, tahini, chickpeas, lime juice, lime zest and salt in a high-speed blender and blend on low for 30 seconds, until very smooth.

3. Combine all ingredients for the limey cucumbers in a medium bowl and stir until cucumbers are well coated with the lime juice. Set aside until you are ready to serve.

4. To make the lamb and squash, add the ground lamb to a heavy-bottom skillet or sauté pan over medium-high heat, and break apart until it is covering the bottom of the pan. Sprinkle with sea salt. Brown on one side for about 8 minutes without mixing, then flip over lamb and finish cooking the rest of the meat.

5. Once meat is browned and cooked, add the zucchini, yellow squash and ras el hanout to the pan. Sauté the mixture over medium-high heat for about 7 minutes until squash is tender. Remove from heat.

6. To serve, first smear about a fourth to a half cup of hummus into the bottom of the bowl, then add lamb and zucchini and top with a large scoop of limey cucumbers. Finish with olives and olive oil (if using) and serve the snap peas on the side for dipping.

Hummus
2 cups chopped golden beets

2 tablespoons tahini

2 (15-16 ounce) cans of chickpeas, strained and rinsed

The juice and zest from 2 limes

1 teaspoon sea salt

Limey cucumbers
2 medium cucumbers, diced small

The juice of 2 limes

1 teaspoon sea salt

1 tablespoon fresh dill, minced

1 tablespoon fresh parsley, minced

Lamb and squash
1 pound ground lamb

1 teaspoon sea salt

2 medium zucchini, diced

2 medium yellow squash, diced

1 tablespoon ras el hanout (moroccan spice blend)

For bowl
½ cup of your favorite olives, pitted and sliced

Olive oil, to finish (optional)

½ pound snap peas, for serving

CURRY CAULIFLOWER
with lentil raisin curry salad

MAKES 2 LARGE BOWLS, PLUS MORE LENTIL SALAD

Vegan food has the challenging task of creating deep flavors and delivering all aspects of nutritional needs with plants. Doing this takes commitment to developing flavor and cooking with the intention of creating an umami taste and mouth-feel without meat or dairy. This vegan bowl achieves its umami flavor and mouth-feel by roasting the cauliflower. The cauliflower is complemented with a zesty, spiced, protein-packed lentil salad. Together you won't be missing flavor, nutrition or textures in this veggie-packed bowl.

Cauliflower

1½ tablespoons any curry powder

2 tablespoons olive oil

¼ teaspoon sea salt

1 large head cauliflower, cut into 1-inch florets and pieces

Marinated lentils

2 (15-16-ounce) cans of lentils, strained and rinsed

1 cup raisins, chopped

½ small red onion, finely diced

¼ cup mint leaves, minced

2 tablespoons Thai green curry paste

½ cup olive oil

½ cup lime juice

1 teaspoon sea salt

5 ounces romaine, butter or other similar lettuce, washed and chopped

Additional mint leaves for garnish, chopped (optional)

1. Preheat oven to 375°F.

2. Combine curry powder, olive oil and sea salt in a prep bowl large enough to also hold all of your cauliflower. Stir together until well mixed.

3. Scoop cauliflower into the bowl and toss with the curry oil until the cauliflower florets are well coated.

4. Spread out cauliflower in a single layer onto a baking sheet and place in the oven for 40 minutes, turning and stirring occasionally to get browning on different sides. Bake until cauliflower is slightly soft and lightly browned.

5. While cauliflower is in the oven, make the lentil salad. Combine the lentils, raisins, red onions and mint in a bowl.

6. Add curry paste, olive oil, lime juice and sea salt to a small jar with a lid and shake until well combined. Then pour all of the dressing into the lentil bowl, and stir until everything is well combined.

7. Once cauliflower has finished baking, remove it from the oven and let it cool slightly.

8. Arrange cauliflower and about 3 large scoops of lentil salad on top of lettuce in each of two bowls and garnish with mint (if using) before digging in!

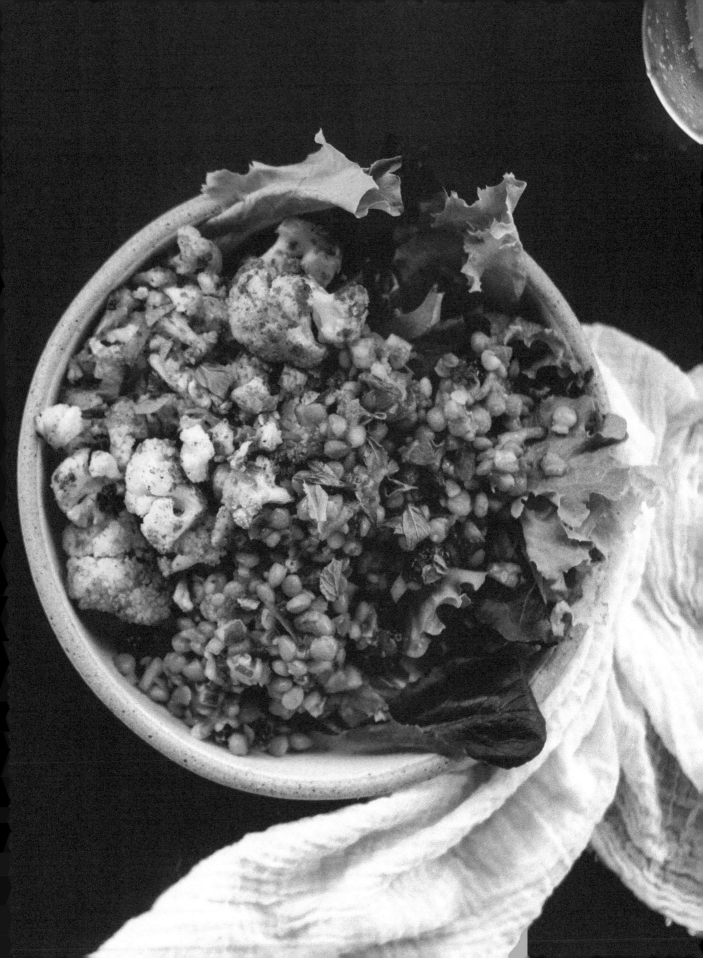

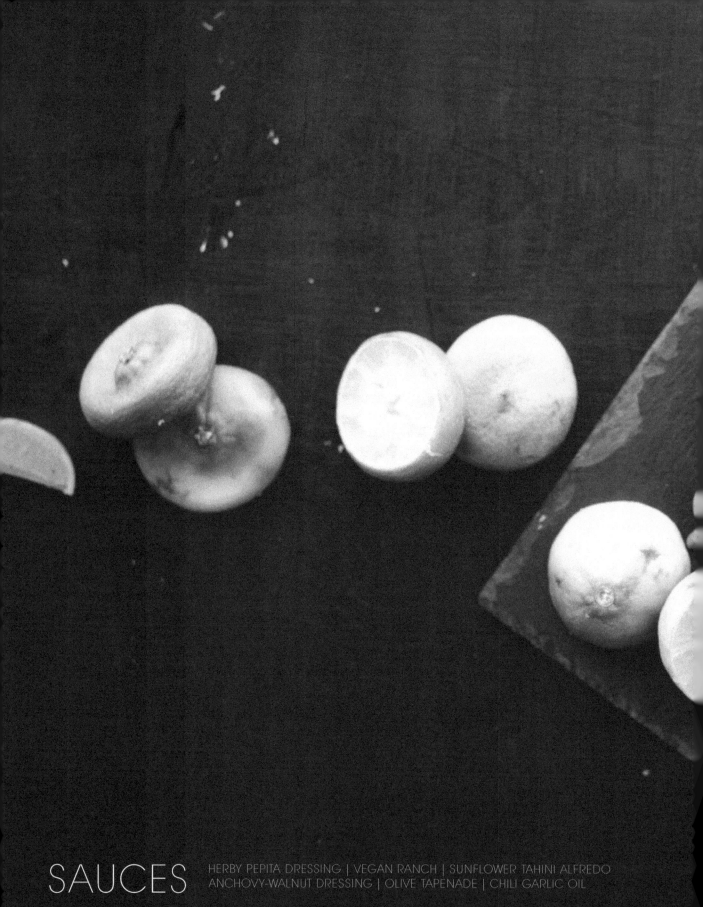

SAUCES

HERBY PEPITA DRESSING | VEGAN RANCH | SUNFLOWER TAHINI ALFREDO
ANCHOVY-WALNUT DRESSING | OLIVE TAPENADE | CHILI GARLIC OIL

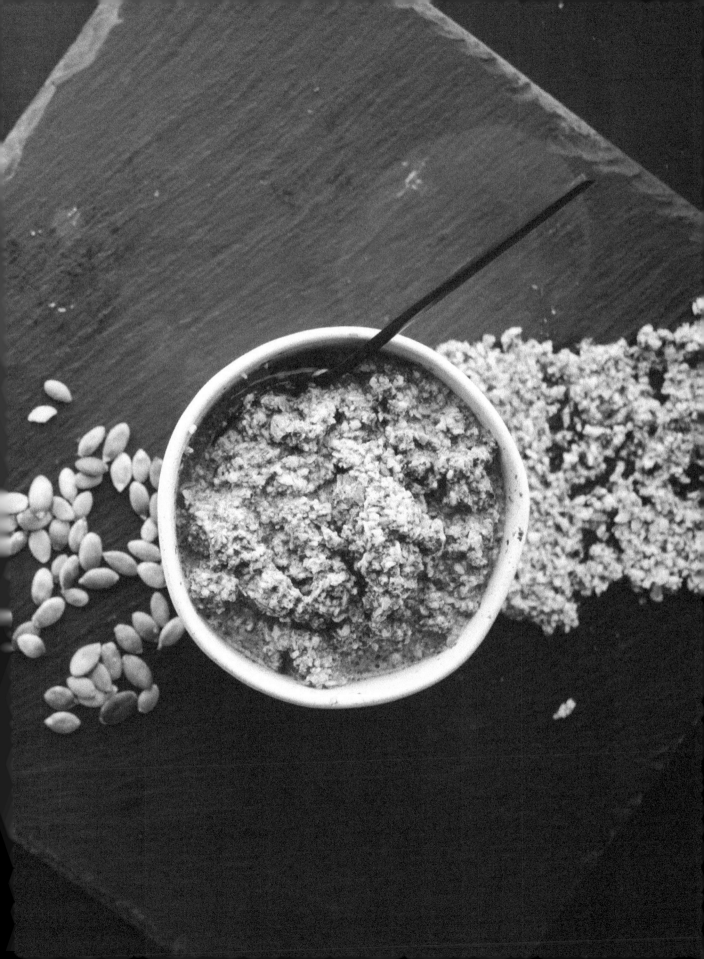

HERBY PEPITA DRESSING

MAKES 4 CUPS
SPECIAL EQUIPMENT: HIGH-SPEED BLENDER

1 large bunch of cilantro, large stems removed (about 4 cups)

1 cup parsley, large stems removed

2 cups pepitas, toasted (see toasting nuts and seeds, page 55)

½ teaspoon sea salt

4 tablespoons lime juice

2 cups water

To prepare sauce, combine all ingredients into a high-speed blender and blend until very smooth. Can be made ahead of time and stored in the fridge for a week.

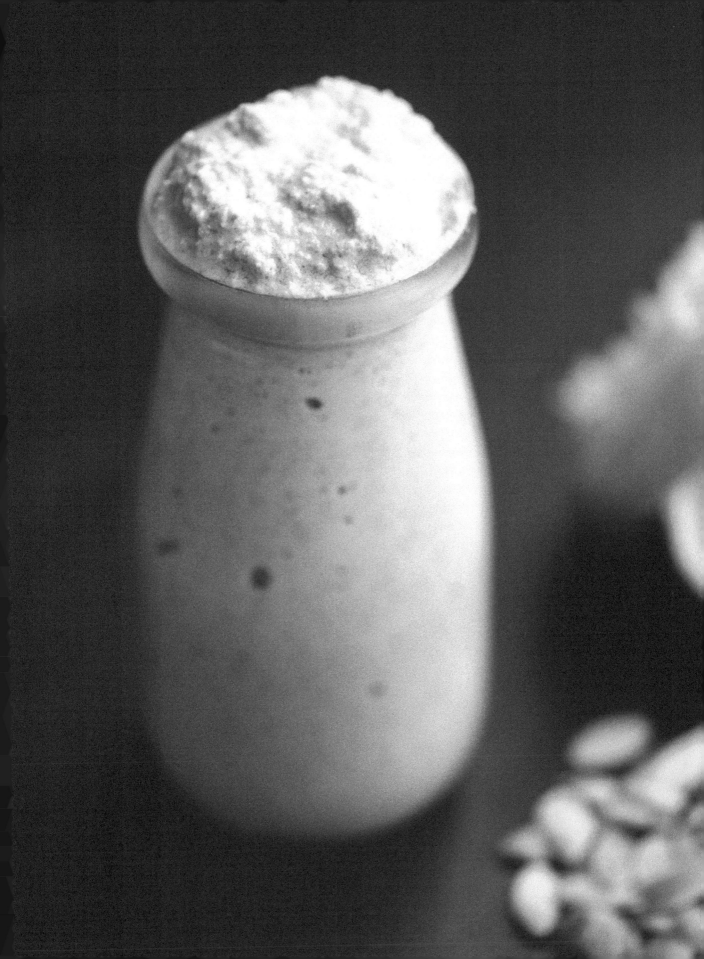

VEGAN RANCH

1 cup raw cashews (no need to soak)

1 clove of garlic

1 cup water

1 teaspoon sea salt

1 teaspoon fresh dill, minced

1 tablespoon fresh chives, diced thin

For the sauce, combine cashews, garlic, water and sea salt in a high speed blender and blend on high until creamy and uniform, about 30-45 seconds. Remove dressing from the blender and then stir in the dill and chives.

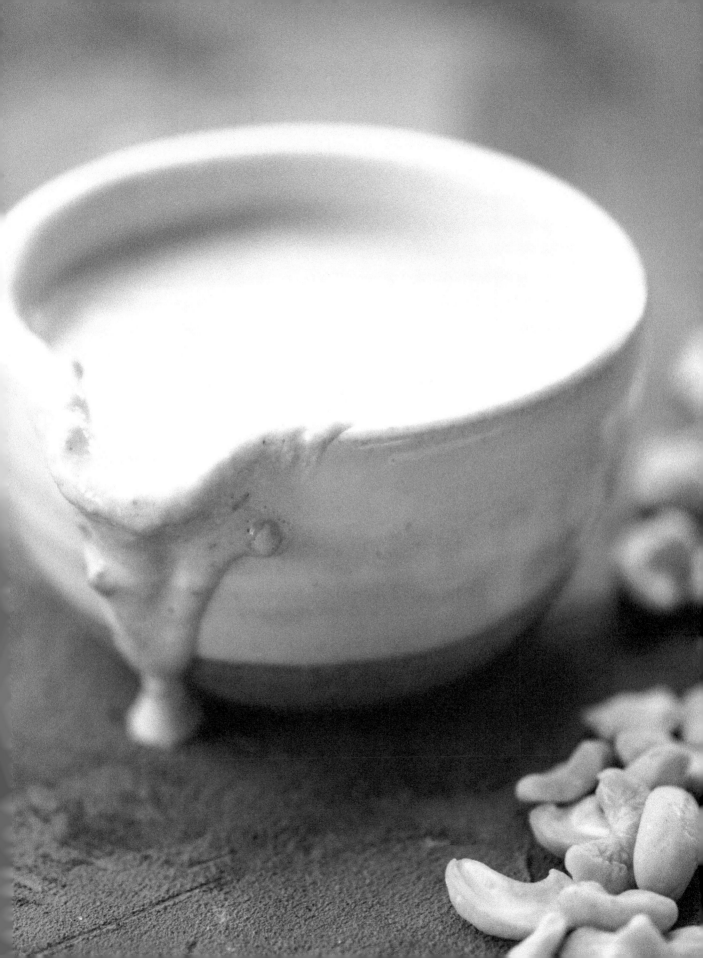

SUNFLOWER TAHINI ALFREDO

MAKES 2 CUPS
SPECIAL EQUIPMENT: HIGH-SPEED BLENDER

2 cups raw sunflower kernels

¼ cup tahini

2 garlic cloves

¼ cup lemon juice

2 tablespoons coconut aminos

½ cup water

½ cup olive oil

1. Add sunflower kernels to a bowl and cover with water. Place bowl in the fridge, covered, for at least 6 hours.

2. Remove the husks from the hulled sunflower kernels by rubbing the sunflower kernels vigorously between your hands before tipping the bowl slightly over a sink and running water over the seeds, allowing the water to overflow and take the floating husks with it.

3. To make the sunflower tahini alfredo, add the soaked sunflower kernels with husks removed and all other ingredients to a high-speed blender and blend until very smooth, about 30 seconds. Transfer sauce to a serving bowl.

ANCHOVY-WALNUT DRESSING

MAKES 1 CUP
SPECIAL EQUIPMENT: HIGH-SPEED BLENDER
PLAN AHEAD: DRESSING CAN BE MADE THE DAY AHEAD AND STORED IN THE FRIDGE

10 anchovies, canned or packed fresh

4 small garlic cloves

2 teaspoons apple cider vinegar

4 tablespoons fresh lemon juice

½ cup olive oil

2 teaspoons coconut aminos

2 tablespoons fresh dill, minced

½ cup walnuts, chopped

Make dressing by combining anchovies, garlic and next four ingredients into a high-speed blender and blend until well combined, about 30 seconds. Remove from the blender and stir in chopped walnuts and dill.

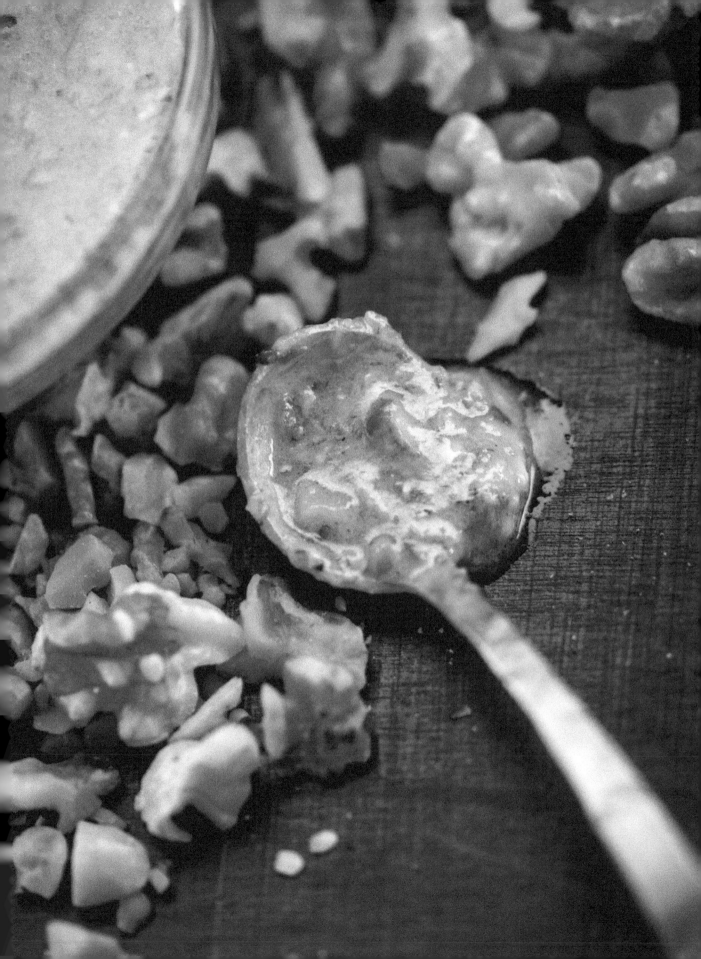

OLIVE TAPENADE

SPECIAL EQUIPMENT: FOOD PROCESSOR
PLAN AHEAD: TAPENADE CAN BE MADE AHEAD AND STORED IN THE FRIDGE

1 pint pitted olives (kalamata, green or a mix of both)

2 garlic cloves

6 sundried tomatoes, dried or packed in oil

2 tablespoons olive oil

3 tablespoons lemon juice

1. Put all ingredients into a food processor and pulse until ingredients are all roughly the same size and evenly distributed.

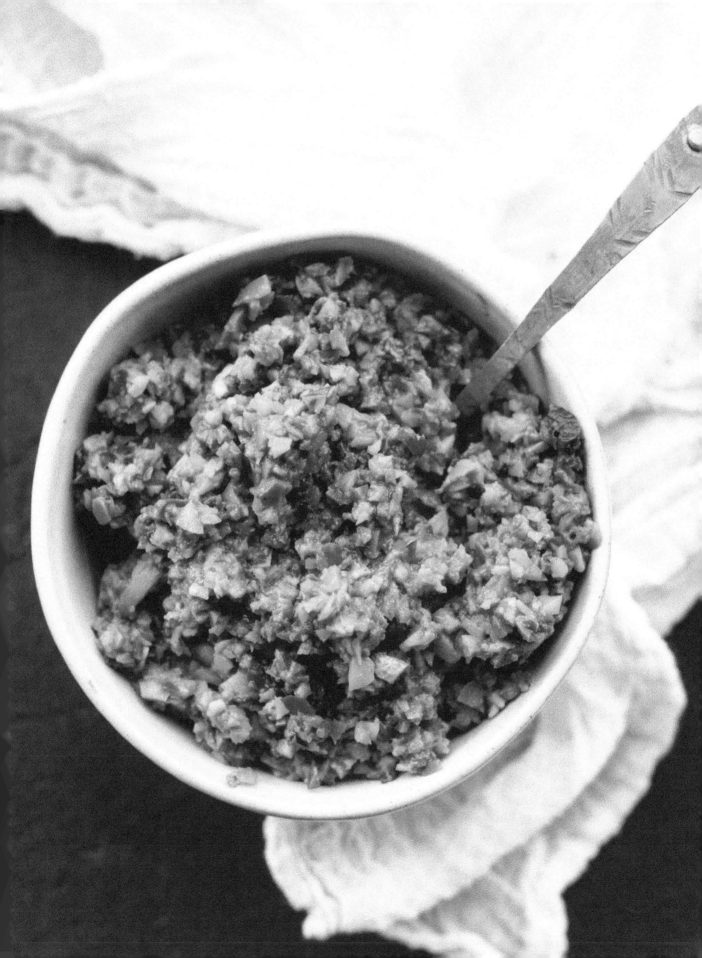

CHILI GARLIC OIL

PLAN AHEAD: SAUCE CAN BE MADE AHEAD OF TIME AND STORED IN THE FRIDGE FOR UP TO TWO WEEKS, JUST STIR OR SHAKE BEFORE USING.

1½ cups avocado oil

2 heads of garlic, cloves removed from paper skin and sliced thin

8 green onions, white parts only and cut into rounds

1 cinnamon stick

3 star anise pods

1 tablespoon aleppo (or similar) chili flakes

3 tablespoons chunky natural peanut butter (just peanuts in the ingredient list)

1 teaspoon coconut sugar

2 tablespoons coconut aminos

1. Heat oil in a small saucepan over medium-low heat. Add sliced garlic, green onion, cinnamon sticks and star anise pods and cook them slowly in the oil until garlic and onion are golden, about 20 minutes. Go slowly with the browning and watch carefully towards the end. Garlic and onions will go from browned to burnt quickly!

2. Combine chili flakes, peanut butter, coconut sugar and coconut aminos in a glass or heat-safe bowl and stir until well combined. Prepare a plate with paper towels layered on top.

3. Once garlic and onions are browned, strain the oil through a fine mesh sieve into the glass bowl with the chili flake mixture and dump the fried garlic and onions onto the plate with the paper towels. Allow the garlic and onions to dry and cool, and discard the cinnamon sticks and anise pods.

4. Once fried garlic and onions have cooled, add them to the glass bowl with the oil and other ingredients and stir until everything is well incorporated.

5. Cover and store in the fridge for up to 2 weeks. Shake or stir well before serving as chili flakes will sink to the bottom.

EPILOGUE - WHERE TO GO FROM HERE

Now that you have experimented with the four pillars of bowl building, and seen smorgasbowl recipes in action, where do you go from here? How do you take these concepts and start incorporating them into your meals? Here are some ideas to get the creative wheels turning on how to repurpose leftovers from the recipes you cook, and ways to mix and match the components in the recipes to create entirely new meals. Starting meal preparation with what you have available or imagining what one component would be like paired with another is where the smorgasbowl magic starts to make your life easier by affording you the pleasure of cooking less and/or customizing. The variations are endless, but here are a few ideas to get you started.

If you have leftover:

Sunflower tahini alfredo (page 106), add steamed veggies and noodles and stir together for a weeknight pasta

Veggies from the nicoise salad (page 36), put them in a skillet with some butter or oil until heated then add beaten eggs and cook through for a breakfast hash. Add any of the sauces on top for bonus flavor!

Spiral sweet potato noodles (page 86), reheat them in a skillet with spinach and add berries for a light breakfast.

Marinated curry lentil salad (page 98), pan fry a tilapia filet and add the marinated lentils and some greens for an easy dinner.

Millet (page 30), put together a greens salad and add the warmed millet and dressing of your choice.

Try these recipe components together:

Replace the dressing on the **Winter fruit salad** (page 71) with the **Honey mint syrup** (page 66)

Taco ground beef (page 76) with the **salad** and **dressing** from the **Cajun salmon bowl** (page 75)

Grilled veggie salad (page 78) with **eggs** (page 53) or **egg whites** (page 51)

Tilapia (page 88) with **Fresh tomato mixture** (page 46) and **Millet** (page 30)

Add the **Mediterranean tilapia** (page 88) or the **Cajun salmon** (page 75) to the **Spiralized salad** (page 62)

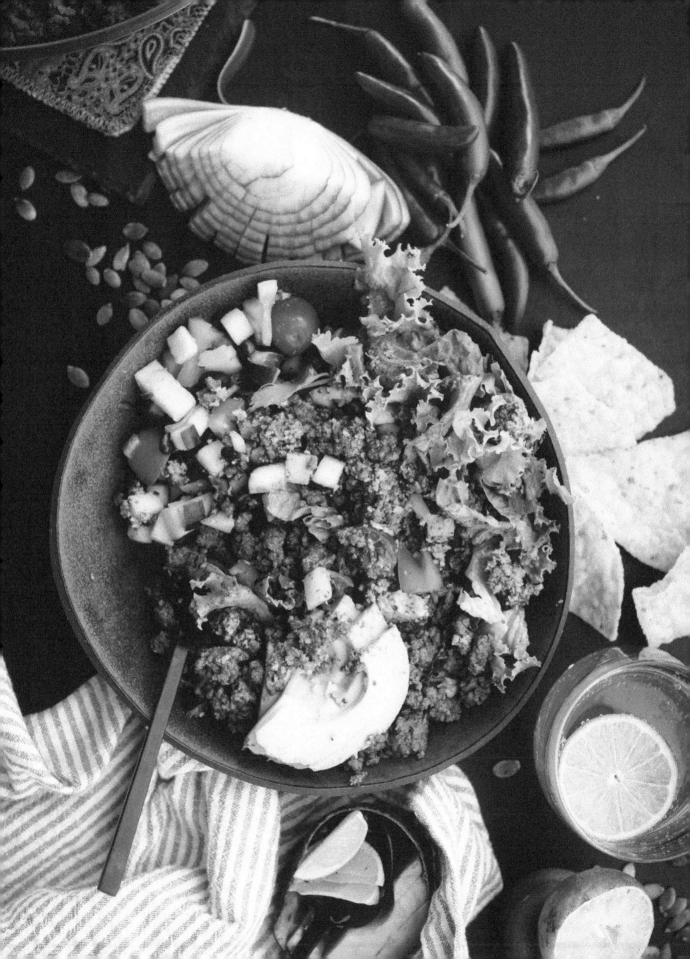

ABOUT THE AUTHOR

Caryn Jeanne Carruthers is a food lover and artist of many mediums. Her passion for healthy eating and her love of cooking started young and flourished when faced with food allergies and sensitivities. She believes food is love and shares her recipes and creations in that spirit. Caryn authors the blog tastynfree.com where she shares her photography, recipes and thoughts on gluten free, dairy free and refined sugar free food. Smorgasbowl is Caryn's first book where she has enjoyed the challenge of creating the book in its entirety, including the photography, cooking, styling, recipe creation, book design and writing. She was born and raised in Colorado and currently lives in Austin, TX with her husband, two kids and two dogs. If you'd like to reach out and connect with her, you can find her on Instagram: @tastynfree.

(Photo credit to *Cynthia Alexandra)*

GRATITUDE

To my children and husband for their never-ending support and good-sport

nature with everything I put on the table,

To my husband for being my best friend, thought-partner and penguin,

To Ann, for your encouragement, support and coaching,

To my family for continuing to ask how my book is coming along,

To Emma, Risa and Theo for the summers of childcare these pages have required,

To Kristin for your keen eye, attention to detail and commitment to inclusion,

To Mackenzie for your time, encouragement and support early on in this project,

To my recipe testers who brought so much energy to this book,

To Tiffany and her team for helping me finally cross the finish line,

To the people who have encouraged me and guided me,

To the bloggers and food publications where I have found inspiration over the years,

And to all the readers.... Thank you from the bottom of my heart for

adventuring with me as we discover all that smorgasbowls can be.

INDEX

Lightning Source UK Ltd.
Milton Keynes UK
UKHW021018030622
403929UK00002B/68